CW00687997

The Decorative Art of
Japanese

FOOD
CARVING

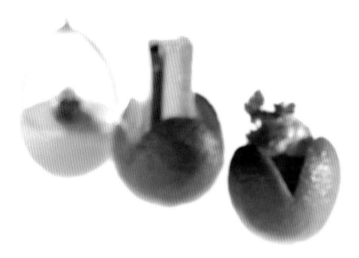

The Decorative Art of Japanese

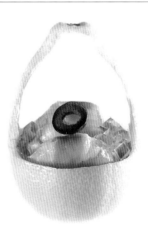

KODANSHA USA

FOOD CARVING

Elegant Garnishes for All Occasions

Hiroshi Nagashima

Photography by Kenji Miura

The publisher would like to express its gratitude to the staff of Shisui restaurant for their unfailing generosity and support, and also to basket artist Setsuko Isohi, collector Yuji Okubo, and the Hanabako Gallery in Tokyo for granting permission to use the elegant basket on page 70.

■ ■ ■

The ceramic work of Shiro Tsujimura appears on pages 33 and 51.

Published by Kodansha USA, Inc.
451 Park Avenue South
New York, NY 10016

Distributed in the United Kingdom and continental Europe
by Kodansha Europe Ltd.

First edition published in Japan in 2009 by Kodansha International
First US edition 2012 by Kodansha USA

16 15 14 13 12 5 4 3 2 1

 The Library of Congress has cataloged the earlier printing as follows:

 Library of Congress Cataloging-in-Publication Data

Nagashima, Hiroshi
 The decorative art of Japanese food carving : elegant garnishes for all
occasions / Hiroshi Nagashima ; photography by Kenji Miura. -- 1st ed.
 p. cm.
 Includes bibliographical references.
 ISBN 978-4-7700-3087-0
 1. Garnishes (Cookery) 2. Vegetable carving. 3. Fruit carving. 4.
Cookery, Japanese. I. Miura, Kenji II. Title.
 TX740.5.N32 2009
 641.5952--dc22
 2009010859

www.kodanshausa.com

CONTENTS

INTRODUCTION

In Japan, taste and visual appeal walk hand in hand to the table. Home cooks and professional chefs alike pay attention to presentation because they consider it a large part of the dining experience. Visual appeal *heightens* the eating experience, whether in a five-star restaurant or at home. A key element of this approach is *mukimono*—the decorative food garnish that delights the eye by adding a final flourish to a dish.

Although the art of Japanese food decoration has yet to escape the confines of Japan's island culture, with this book I hope to change all of that. I hope to bring this new and exciting way of treating food into your kitchen. Food art gives me immense pleasure and it can do the same for you. It can change the way you look at your "daily bread." It can bring a new level of enjoyment and appreciation into your kitchen. You will delight in its playful elegance and visual appeal, and those you feed will be astonished by your creations.

This book is all about bringing creativity into your food practices and making cooking fun again. If working with food is already an inspiring activity, the garnishes and decorations in these pages will lead you in new directions. They will allow you to add flourishes to your cooking repertoire in a manner you never considered. They will lend a whimsical

charm to your food in some instances, an understated elegance in others. More importantly, they will jumpstart your curiosity and send you off on new, unexplored tangents.

The more than sixty garnishes range in scale from simple—made in seconds—to elaborate, with every imaginable level in between. Many are easily mastered. Others require practice and skill. You'll find potential uses for most of them. All of them will shine on special occasions. I know. I've tested them over and over again. If you are presenting your meal on a single plate with two or three items, choose a garnish appropriate in color, shape, and taste for the collective food display. I discuss how colors work on the plate and how to combine them in various places throughout the book. If you are serving courses, select a garnish for each round—appetizer, soup or salad, main course, dessert. As far as tools go, most garnishes require only a sharp knife and possibly a few everyday utensils. A handful require specialized implements.

But this collection of edible garnishes represents only the beginning of your culinary journey. For over and above everything else, *The Decorative Art of Japanese Food Carving* is an idea book. These pages overflow with suggestions and inventive ideas you can use as springboards to even more daring, more inventive decorations or food combinations. In each of these projects, along with the Recipe Notes at the back, you'll find a place to flex your culinary muscles and challenge your cooking skills.

For starters, I offer further suggestions for most of the garnishes. Instead of a daikon radish, use a carrot. Instead of a lemon, use a lime or an orange or a pink grapefruit. Instead of the Japanese pumpkin I chose because I wanted readers to become aware of its natural sweetness, use a local squash or a green pepper or something else *you* notice close at hand. You, too, should think in terms of expanding the basic idea of each decoration by trying it on new foods around you.

Next, every garnish in this book can decorate dozens of dishes, not just the one selected. For example, I chose to incorporate the Fluttering Plum Blossom on page 62 in a salad, but this delicate garnish could easily be sprinkled over a leafy green salad, arranged along the edge of a fish or steak dinner, set elegantly alongside a slice of cake or, perhaps, floated in a pitcher of lemonade or iced tea. The combinations are endless, subject only to the limits of your imagination.

The art of Japanese food decoration extends back hundreds of years. The tradition is long and grand. But then, as now, it took a willing hand and a fertile mind to work the knife and dress the table in a way that captured the audience, whether they were six or sixty. In that respect, not much has changed. In another respect, everything has changed. The eager cook has so much more at his or her fingertips. An ever-growing selection of vegetables from around the world can be found at your grocers or at some of the specialty shops in town. Carrots in hues from yellow to red to purple are now available. Japanese radishes and cucumbers have traveled across the seas. Using peppers and zucchini and other vegetables of varying shapes and colors can be explored. And if you can't find what you want at your greengrocer's, you can acquire seeds at your local nursery or online, and grow it in your garden.

For the adventurous cook, truly these are blessed times. So take the new techniques and ideas introduced here and run with them! Transform the way you think about food. Enhance your kitchen skills. Play with your meals—their presentation, the shapes of the foods, and the colors on which the eyes can feast. In short, with new vigor and inspiration, create, eat, and enjoy!

Hiroshi Nagashima

SIMPLE ACCENTS

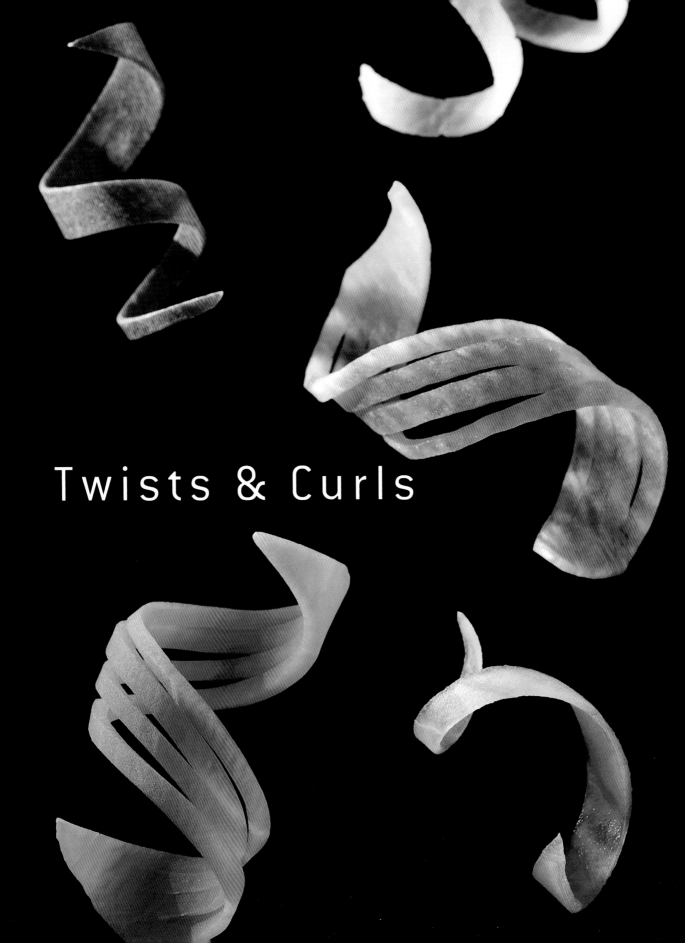

Twists & Curls

Simple Twist

Twists and curls provide a splash of color that appeals to the eye and enlivens the overall arrangement, which in turn stimulates the palate. Here, they garnish three individual portions of sashimi—shrimp, tuna, and red snapper, which have been set in a variation of the Morning Glory pattern introduced on page 48. This elegant presentation will enhance any combination of appetizers. Keep the portions in the Daikon Cups reasonable and these cups are easily lifted with the fingers and eaten as is.

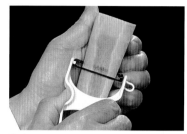

1 | Cut a 4-inch (10-cm) length of carrot in half lengthwise, then cut off a length with a peeler.

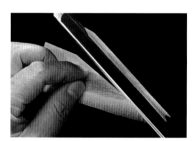

2 | Cut off ⅛-inch (3-mm) slivers at a diagonal.

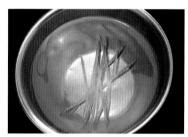

3 | Soak the slivers in water for 1 or 2 minutes. The carrot will absorb the water and become more pliable.

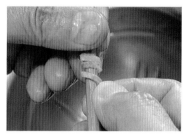

4 | Wind a carrot sliver around a thin stick (a chopstick works well).

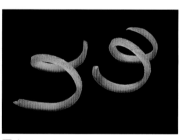

5 | Unwind and adjust twist to make the final shape.

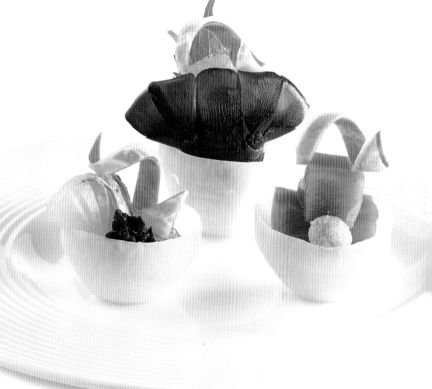

Sashimi Platter

Ocean Wave Curl

This tender abalone steak rests on a bed of asparagus and potato. Adding a glazed carrot garnish brightens this inherently dark-toned dish, and the unexpected splash of color raises the level of the diner's anticipation. Twists and curls offer a wide range of color and culinary opportunities, particularly if you take advantage of vegetables such as cucumber, daikon, and carrots (this last, in all the available hues—yellow, orange, red, and purple). How effective is this simple garnish? Cover the Ocean Wave and you'll immediately understand the simple appeal of this culinary flourish, which requires minimal effort but enhances the dining experience immeasurably.

1 | With a knife or peeler slice off a 1-inch-wide (2.5-cm) strip of carrot. Trim end by making a diagonal cut.

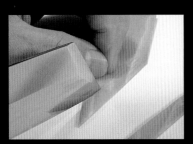

2 | Make 4 slits in the carrot, each less than ⅛ inch (2 mm) apart. Do not cut to the edges, but leave about ⅙ inch (4 mm) at both ends uncut.

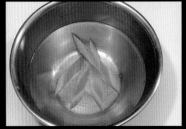

3 | Soak in water for 1 to 2 minutes to soften.

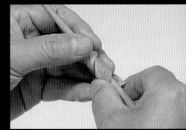

4 | Wrap around a stick to curl.

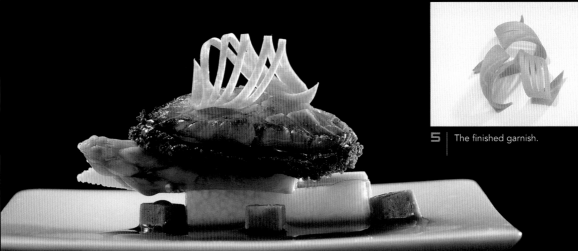

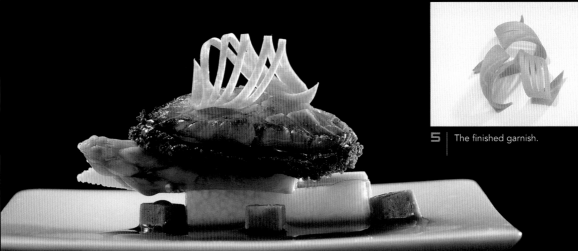

5 | The finished garnish.

Tube Curl

The Tube Curl brings this dish to life with a simple, elegant flourish, lending color and movement to what would have otherwise been a linear, bland-looking presentation. Try sprinkling Tube Curls over a favorite salad or meat dish. Depending on the dish, consider using cucumber, a red or yellow carrot, or a firm vegetable of your choice.

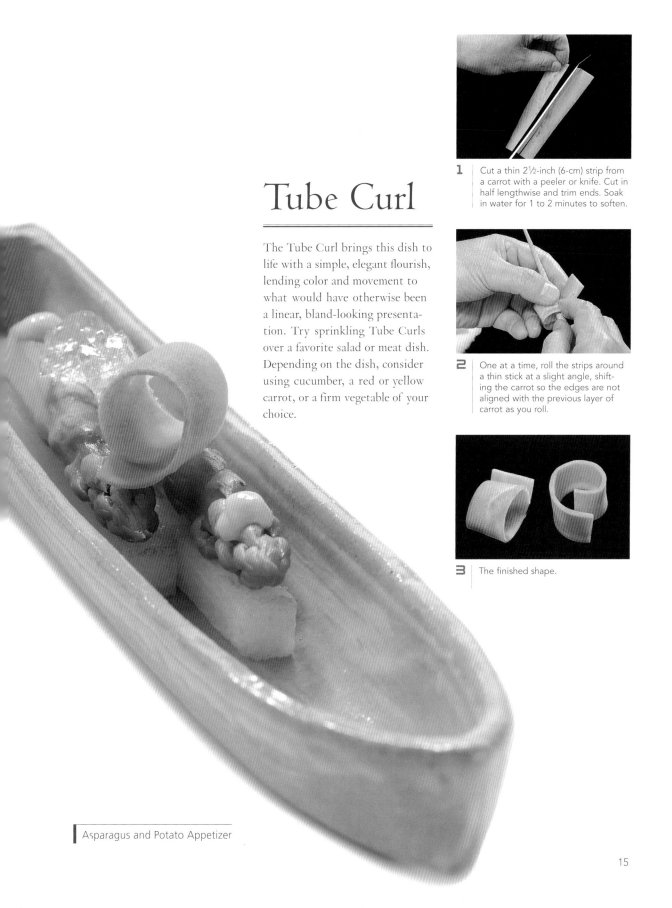

1 | Cut a thin 2½-inch (6-cm) strip from a carrot with a peeler or knife. Cut in half lengthwise and trim ends. Soak in water for 1 to 2 minutes to soften.

2 | One at a time, roll the strips around a thin stick at a slight angle, shifting the carrot so the edges are not aligned with the previous layer of carrot as you roll.

3 | The finished shape.

| Asparagus and Potato Appetizer

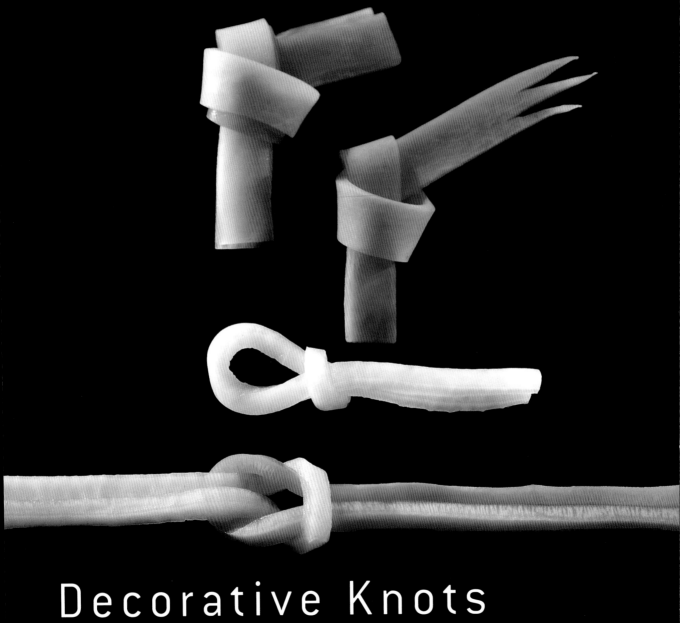

Decorative Knots

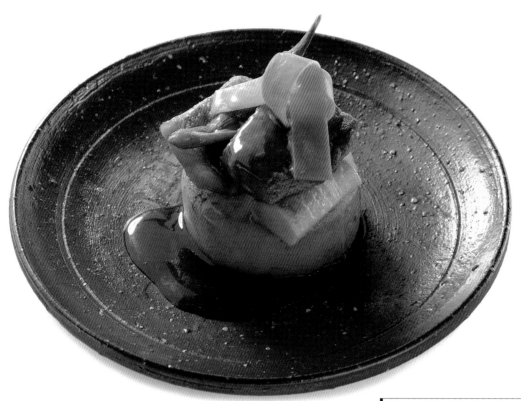

Japanese Knot

Once again a glazed carrot garnish decorates rich foods and tantalizes the eye. This knot-shaped garnish was inspired by an ancient traditional way of sending notes or missives. Once written, the paper was folded into a long rectangular shape, then knotted to form the distinctive pentagonal lozenge at the center. This charming garnish adds a splash of color to any main course, and here enlivens the more subdued tones of this dish. It can be made with any similarly textured vegetable, including turnip and daikon.

1 Cut a thin, 4½-inch (11-cm) length from a carrot then cut into ½-inch-wide (1.3-cm) strips. Soak in a strong saltwater solution (3 tbsp salt to 1 cup/ 240 ml water) for 1 to 2 minutes.

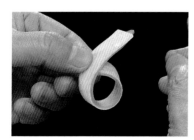

2 This garnish can be made with a second layer of vegetable such as daikon. If you choose to use a second vegetable, prepare as in step 1, trim to the same size, then begin knot as shown.

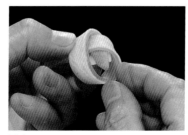

3 Push end through loop and . . .

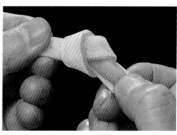

4 . . . pull and shape to finish. Rinse off the saltwater.

Knotted Ribbon

Here a thick, juicy slice of daikon radish creates an island, breaks up the solid red field, and acts as a platform to display a sampling of vegetable—including the edible Knotted Ribbon garnish. The daikon and carrot add visual appeal to what would otherwise have been a forgettable presentation. Notice, too, how the orange of the carrot nicely bridges the red of the soup and the startling whiteness of the radish. Try this technique with other soups to confound the expectations of your diners.

Beet Soup

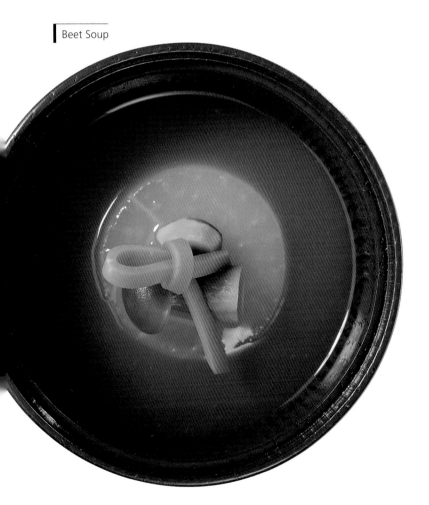

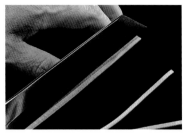

1 | Cut a thin, 6-inch length (15 cm) of carrot, slice off thin ⅛-inch strands (2–3 mm), then soak in saltwater (3 tbsp salt to 1 cup/240 ml water) for 1 to 2 minutes.

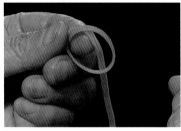

2 | Bring one end around and over the other to make a loop, then push the strand through the loop.

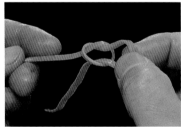

3 | Pull the strand from the middle to form the final loop as the knot tightens.

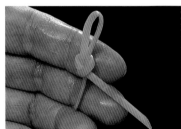

4 | The finished garnish. Be sure to rinse off the saltwater. Part of the charm of this decoration lies in its uneven ends.

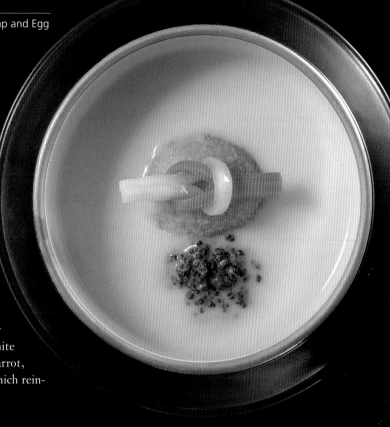

Lucky Knot

The island technique is used once again to great effect, but here it provides a subtle base of support for the garnish. The yellow island bridges the color gap between the white of the potage and the brashness of the carrot, reined in by the pure white daikon loop, which reinforces the sense of freshness.

1 | Cut a 5-inch (12.5-cm) length of carrot.

2 | Cut a length of daikon to the same size and soak both vegetables in salted water (3 tbsp salt to 1 cup/ 240 ml water) for 1 or 2 minutes.

3 | Cross the ends of the carrot as shown to form a loop. Do the same with the daikon and pass the daikon loop over the carrot ends. Insert the daikon ends through the carrot loop.

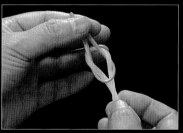

4 | Gently pull to form a knot, making sure each strand has no twists.

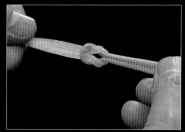

5 | Pull the knot firmly but not too strongly to finish. Shape the knot with your fingers if necessary. Rinse away the saltwater.

19

Refreshing Accents

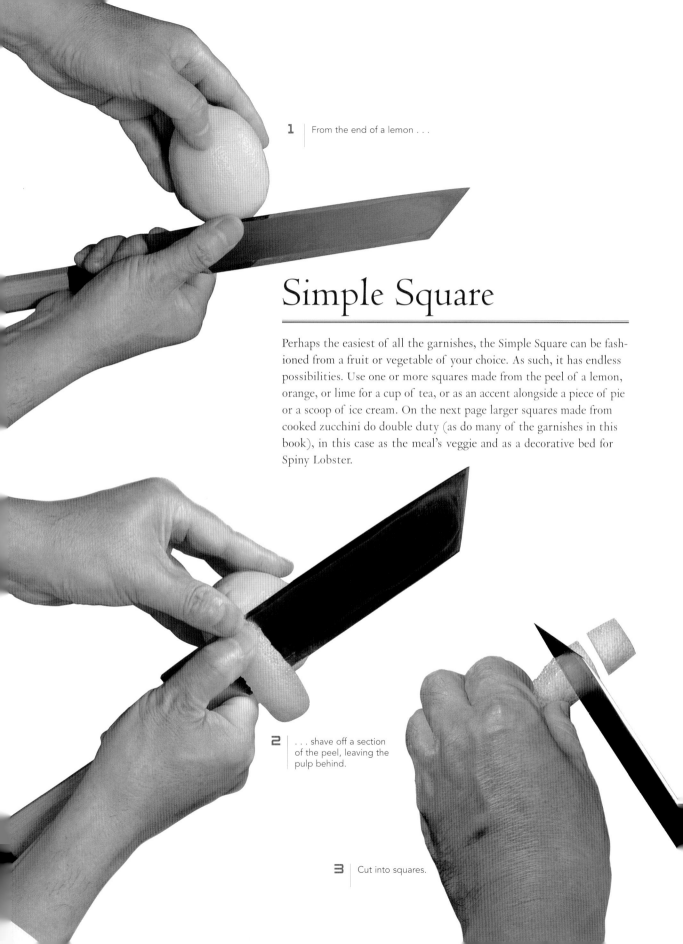

1 | From the end of a lemon . . .

Simple Square

Perhaps the easiest of all the garnishes, the Simple Square can be fashioned from a fruit or vegetable of your choice. As such, it has endless possibilities. Use one or more squares made from the peel of a lemon, orange, or lime for a cup of tea, or as an accent alongside a piece of pie or a scoop of ice cream. On the next page larger squares made from cooked zucchini do double duty (as do many of the garnishes in this book), in this case as the meal's veggie and as a decorative bed for Spiny Lobster.

2 | . . . shave off a section of the peel, leaving the pulp behind.

3 | Cut into squares.

Pine Needle & Maple Leaf

For a dish as grand as lobster, the garnishes have been piled on—a maple leaf of apple, a pine needle from cucumber above, and overlapping Simple Squares of zucchini below. The natural attributes of the lobster contribute to the visual effect of this dish, so the garnishes need to complement without clashing. The garnishes sandwich the lobster in greenish hues that echo the dark green of the tableware, while the red maple leaf draws together the various shades of orange and yellow.

1 Cut off a 1-inch-wide (2.5-cm) strip of a lemon peel, then slice into ¼-inch (5-mm) widths, shaping the triangular end before or after.

2 Make an incision below the triangular head . . .

3 . . . then cut lengthwise to form one side of the pine needle. Repeat on the other side.

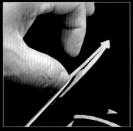

4 Cut down the middle to finish.

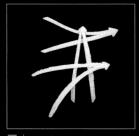

5 The finished garnish.

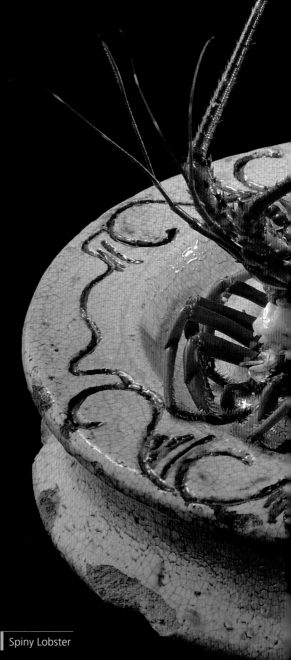

Spiny Lobster

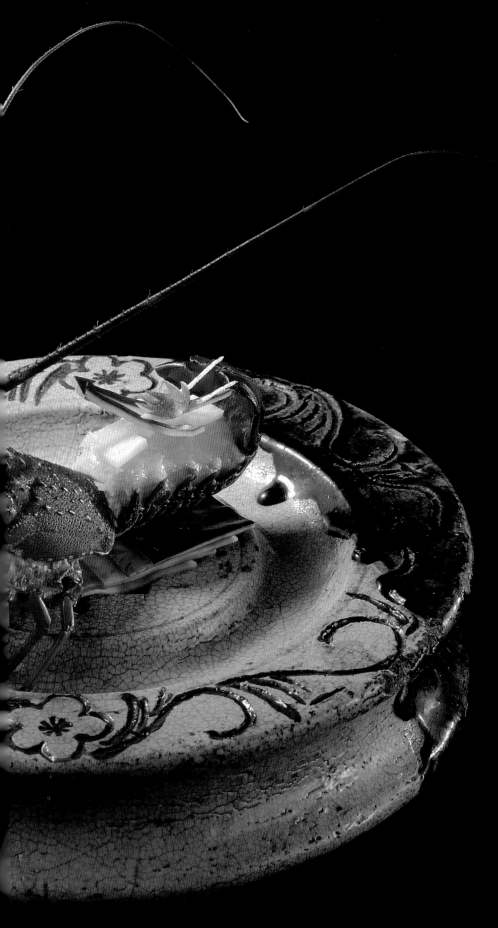

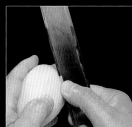

1 With a kind of rocking motion, cut the first finger of the leaf . . .

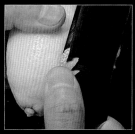

2 . . . then shift the knife and cut again to form the remaining fingers.

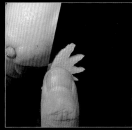

3 Make the final cut to sever and complete the leaf.

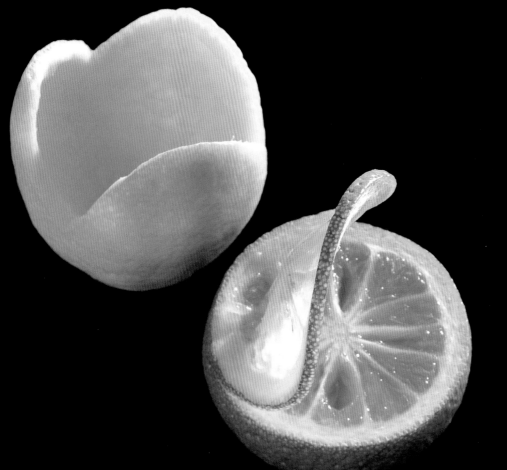

Food Cups

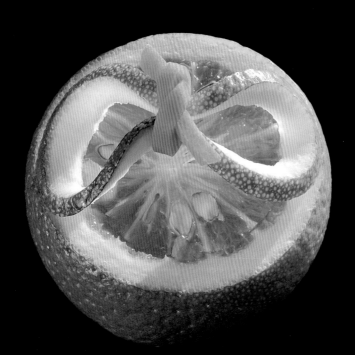

Covered Food Cup

A tantalizing mouthful of game meat set on a wedge of fresh lime makes for a visually pleasing and zesty opener to any meal or party. Try this set piece with lightly grilled chicken or fish, or any seafood favorite such as shrimp, scallop, or crab. Just a sprig of parsley or other leafy green brings this food cup to life. Group together on a platter for a centerpiece display. Try oranges and lemons and mix and match, depending on the food topping.

Roast Duck on a Half Lime

1 | Trim the bottom of a lime so it will stand on its own.

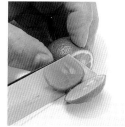

2 | From the top, trim away slightly less than ¼ of the lime.

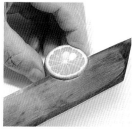

3 | Make an incision ⅛ inch (3 mm) from the top, leaving ¼ inch (6 mm) at the back end.

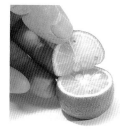

4 | Lift flap to insert food.

Food Cup with Twist

The curling twist of this garnish not only provides a dramatic flair for this seafood appetizer, but also adds a vivid third color to this tender serving of lightly seasoned calamari with salmon caviar (*ikura*). Again, any food that would benefit from a splash of lime works well with this decoration, including grilled chicken and most seafood.

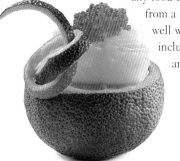

Calamari Topped with Salmon Roe

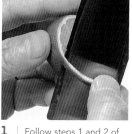

1 | Follow steps 1 and 2 of the Covered Food Cup, then on the top side cut away the peel and pith as shown, following the lip of the lime three-quarters of the way around.

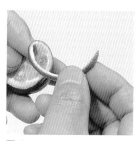

2 | Make a loop with the peel, then . . .

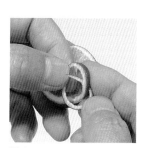

3 | . . . slip the end through loop to complete.

4 | The finished garnish.

Tulip Cup

The deep reservoir of the Tulip Cup lends itself to endless food combinations, from appetizers to salads to a small, palate-cleansing scoop of sorbet. Choose something that blends visually with the lemon. Tulip Cups are also perfect for shrimp cocktails, avocado salad, or many other meal starters. Try making these cups with limes, oranges, or pink grapefruit, or a festive combination of two or three colors.

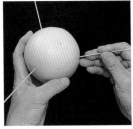

1 Insert three skewers just above the halfway point of the fruit to form a triangle.

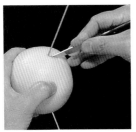

2 Make a steep curving cut from one skewer to the next to form a lip of the tulip petal.

Set skewers in fruit as shown, just above the halfway point.

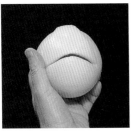

3 Make two more cuts to form the last 2 petals and complete the triangle.

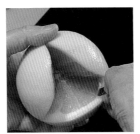

4 Remove the peel and make a shallow cut on the underside of each petal to define the shape.

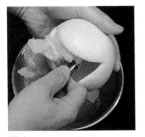

5 Scoop out the fruit.

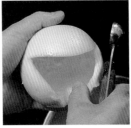

6 A clean cup should be scraped down to the pulp. Trim the bottom.

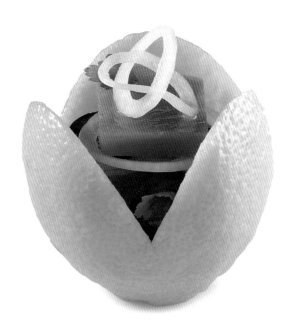

Marinated Salmon with Olive and Onion

Pumpkin Jewel Box

This edible garnish takes advantage of the Japanese pumpkin's natural elegance. The outer green skin has been peeled off and the inside filled with risotto, the popular Italian rice dish, which is then topped with colorful morsels of shrimp and mushroom. The same idea works, of course, for stuffed green peppers and any small pumpkin or squash whose size allows for single servings. The Jewel Box also works well with gratin, onion soup, and other hot foods.

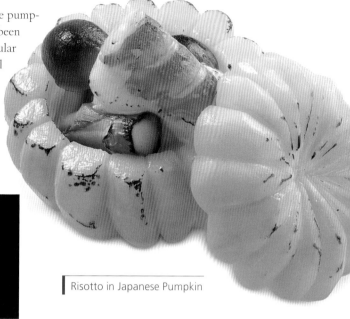

Risotto in Japanese Pumpkin

1 | Peel a Japanese pumpkin as thinly as possible.

2 | Peel carefully and evenly.

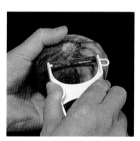

3 | This can also be done with a peeler.

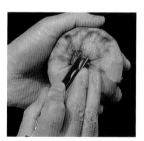

4 | Clean up the remaining peel on the bottom and then score with an X. Remove the peel at the top but do not score.

5 | Score the bottom with 3 more Xs to complete.

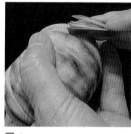

6 | Score the sides of the pumpkin along its natural indentations.

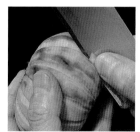

7 | Round off the edges of the scored lines.

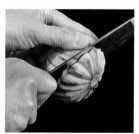

8 | Cut off the top.

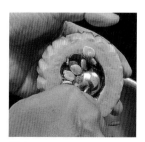

9 | Scoop out seeds and clean the inside.

10 | The finished garnish.

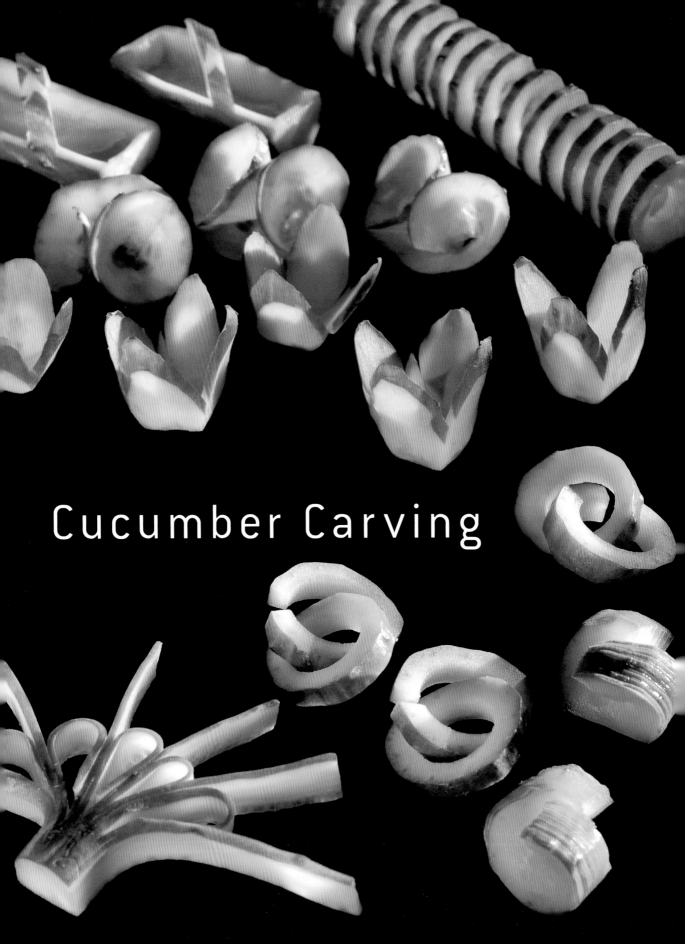

Cucumber Carving

Switchback Cut

The petit, crisp Japanese cucumber is ideally suited for garnishes and appetizers, as it is easy to cut and can be eaten raw. Here it is paired for texture and color with salmon and cheese, but the Switchback Cut could work equally well with small portions of sardine, sliced ham, slivers of bacon seasoned with parsley, and so on. Substitute carrot or other crispy veggies for the cucumber.

1 Cut a 2-inch (5-cm) length from a cucumber.

2 Poke the knife through the middle 1 inch (2.5 cm), leaving ½ inch (1.3 cm) on each side.

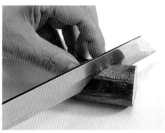

3 Cut at a diagonal to the cut made in step 2.

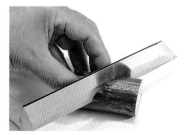

4 Keeping the cucumber on the cutting board, roll it 180 degrees and make a second cut.

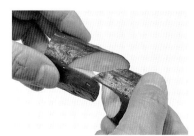

5 Pull apart.

6 The finished garnish. You can create different effects by varying the cuts in steps 3 and 4.

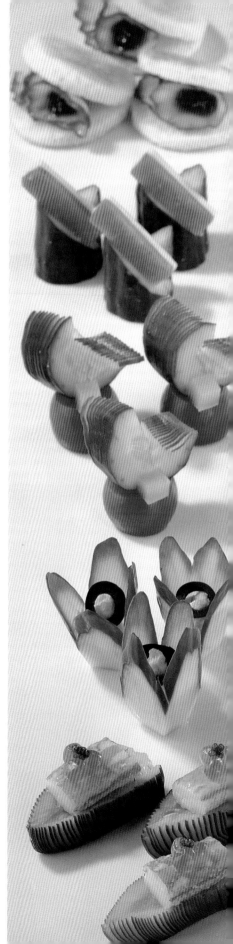

Mini Cups

Dollops of jam and marmalade rest inside the paired Mini Cups as optional condiments for the toast. This is another highly versatile decoration. Try using it to serve condiments for pâté, steak, prime rib, fish, and other main courses, or to hold a dab of butter for a portion of steaming vegetables. Or substitute garlic toast, bagels, muffins, date-nut bread, and other suitable baked goods.

Toast with Jam

1 | Cut the cucumber as if you were sharpening a pencil.

2 | Keeping the center, rotate the cucumber and cut for two and a half rotations.

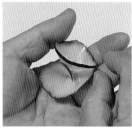

3 | Separate and shape to form two minicups and soak in water for 2 or 3 minutes.

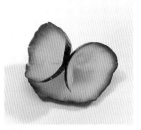

4 | The finished garnish.

King's Crown

Add a mouthful of tuna salad, top with a slice of olive, and you have a charming, fully edible appetizer for any party or occasion. The brilliance of the King's Crown is its versatility. Other simple fillers include baby shrimp, potato salad, or salmon roe (*ikura*). Or consider adding a tasty morsel of one of your personal favorites, perhaps something like Steamed Chicken with Mustard.

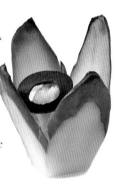

Tuna Salad, Cucumber, and Egg

1 | Trim the bottom of a cucumber by cutting off the bottom tip and then trimming as shown to make 4 sides. Cut the first spike of the King's Crown as shown, leaving ½ inch (1.3 cm) at the bottom uncut.

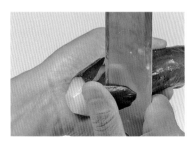

2 | Cut the spikes for the remaining 3 sides.

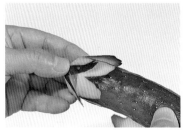

3 | Pull and twist gently to separate the Crown. Soak in water for 2 or 3 minutes or until ready to use.

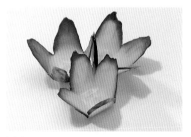

4 | The finished garnish.

Dancing Crane

Japanese cucumber is sliced and twisted to create an image of a bird flapping its wings. The Dancing Crane works well on any salad or alongside a main course of meat, fish, or poultry. Here, when perched atop a cherry tomato for a simple finger food, the bird image is taken one step further.

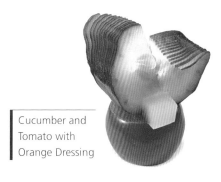

Cucumber and Tomato with Orange Dressing

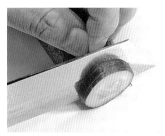

1 In a 1-inch (2.5-cm) length of cucumber, make a series of fine cuts, leaving the last ⅛ inch (3 mm) untouched. For even cutting, lay skewers or chopsticks on each side of the cucumber to stop the blade.

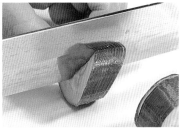

2 Make an incision through two-thirds of the section. Soak in a weak saltwater solution (1 tbsp salt to 1 cup/240 ml water) for 1 minute, then rinse and wrap in a cloth to draw off the rest of the water.

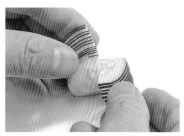

3 Gently spread and shape to create the Dancing Crane.

Leaf Boat Canapé

Here the decorative garnish is *half* of the offering. With its light and relatively neutral taste, the Japanese cucumber provides a wonderful base for any food combination you could think of, whether it involves seafood, meat, poultry, cheese, or even, say, a vegetable pâté. Try making this garnish with raw or parboiled carrot.

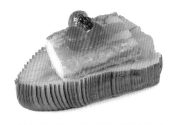

Crab and Cucumber Canapé Topped with Salmon Roe

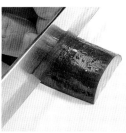

1 Cut a cucumber in half lengthwise, then into 2-inch (5-cm) lengths. Finely score each piece, stopping about ⅛ inch (3 mm) from the bottom. Set skewers or chopsticks along the sides of the cucumber to stop the blade, if necessary.

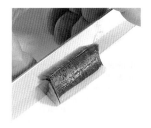

2 Cut in half lengthwise, then soak in a weak saltwater solution for 1 or 2 minutes, then rinse and dry as in step 2 of the Dancing Crane.

3 Shape each side of the boat to make the narrow point of the bow.

4 Bring the two halves together and finish shaping.

Cucumber Rings and Vegetable Twigs

When one garnish is encompassed in the dish itself, it opens the door to a second garnish, in this case Vegetable Twigs. The Cucumber Rings add movement and a second hue to the crepes. The multicolored twigs contribute a playful touch and a rainbow of natural colors. For a colorful salad or similar dish, consider stringing together a small chain of rings or sprinkling veggie twigs over the top.

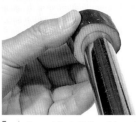

1 | Cut a 1-inch (2.5-cm) length of cucumber and punch out the center with a round cookie cutter, punch, or apple corer. Cut into 4 rings.

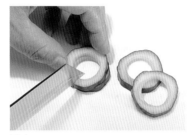

2 | Make an incision in 2 of the rings.

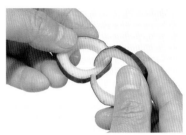

3 | Link 2 rings to make a chain.

Dinner Crepes with Japanese Eel

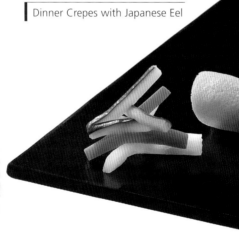

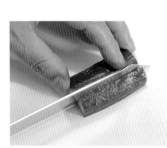

1 | Cut a 1-inch (2.5-cm) length from the top of a cucumber, about ¼ inch (5 mm) high. Cut off a ¼-inch-wide (5-mm) strip from the side.

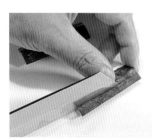

2 | Make 2 incisions as shown, cutting nearly to the top as shown in step 3.

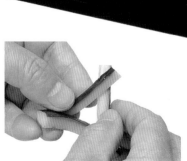

3 | Spread the side pieces and . . .

4 | . . . tuck 1 side under to finish Vegetable Twig, then soak in water for 2 or 3 minutes.

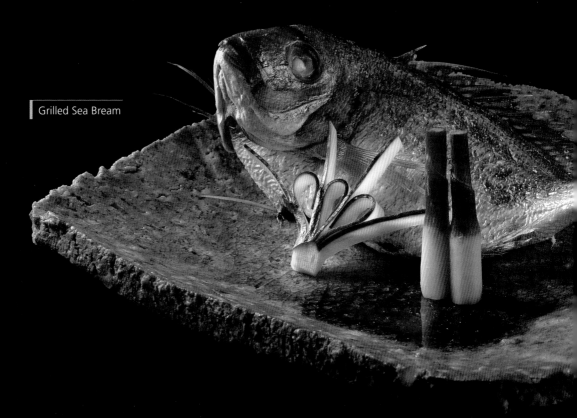

Grilled Sea Bream

Japanese Fan

Here the tableware and fish provide a pleasing range of colors from yellow to green to brown. The red tops of the ginger sticks complement the brown, so the Japanese Fan garnish needs only to pique visual interest with movement and form. An additional benefit is the way it draws in the greens and yellows. Any simple slab form, whether meat or fish or vegetable, is easily enlivened with this garnish.

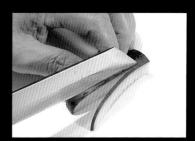

1 | Cut a 2-inch (5-cm) length from the top of a cucumber, about ½ inch (1.3 cm) high and ½ inch (1.3 cm) wide. Make 6 cuts and even widths (about ¹⁄₁₂ inch/2 mm).

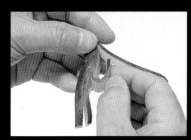

2 | Fold in every other leaf to make loops.

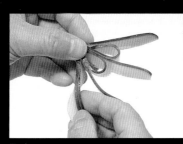

3 | Make 3 loops.

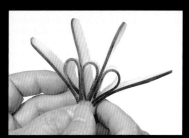

4 | Remove the peel from the base of the Fan. Soak in water for 30 seconds.

Cucumber Corkscrew

Here is another instance where the garnish is incorporated into the food offering, in this case an intriguing hors d'oeuvre with a number of easy-to-make possibilities. Choose alternative stuffings with their color and texture in mind. After a few trial runs, this garnish can be made in a matter of seconds.

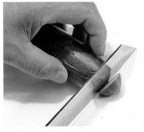

1 | Trim both ends of a cucumber.

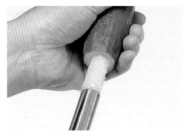

2 | Core the cucumber with a punch or an apple corer.

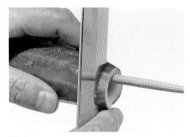

3 | Insert a chopstick or skewer into the center, insert knife, and . . .

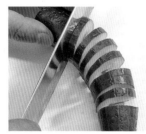

4 | . . . then rotate cucumber while moving the knife forward to make spiraling corkscrew shape.

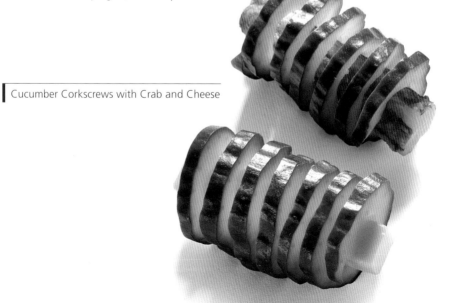

Cucumber Corkscrews with Crab and Cheese

Cucumber Basket

This charming basket shape is inspired by the traditional bamboo basket, a sight once common throughout Japan. Here the cucumber boats carry sardines in two different sauces—tomato and orange. Whether using seafood, poultry, meat, or, say, slivers of mushroom, the challenge for the cook is to fill the baskets with complementary sauces that create a picturesque mosaic of color.

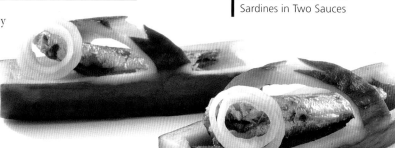

Sardines in Two Sauces

1 | Start with a 3-inch (7.5-cm) length of cucumber. Cut a ⅓-inch-wide (8-mm) handle in the center of the cucumber. The blade should penetrate about one-third of the cucumber.

2 | Turn the cucumber cylinder on its side and trim away the top half of basket on both sides of the handle.

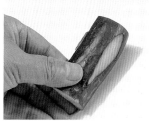

3 | Trim the bottom so the basket will be stable.

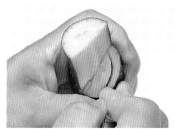

4 | Carefully carve out the underside of the handle, hollowing out one side and then . . .

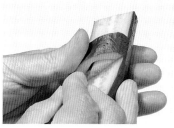

5 | . . . turning the basket around and finishing the other. This is delicate work, so proceed cautiously.

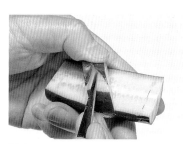

6 | Decorate the handle, supporting the underside with a finger if necessary.

7 | Make incisions to mark out the interior of the basket and then . . .

8 | . . . carefully scoop out to make a cavity.

9 | The finished basket.

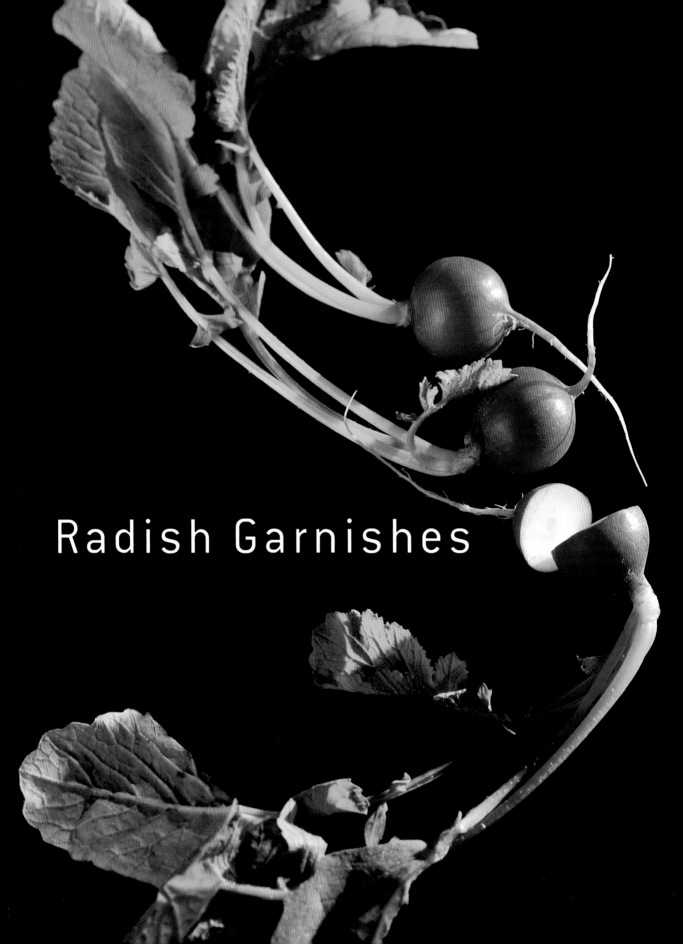

Radish Garnishes

Jeweled Radish

All three of the radish garnishes here are simple to make. Of the three, perhaps the Jeweled Radish is the most elegant. The effective use of the startling contrast between the red skin and the white flesh is what gives the garnish its charm. The technique is equally attractive with other vegetables or fruits that offer such colorful contrasts. Note how the green top has been pruned back but not discarded for an additional flourish.

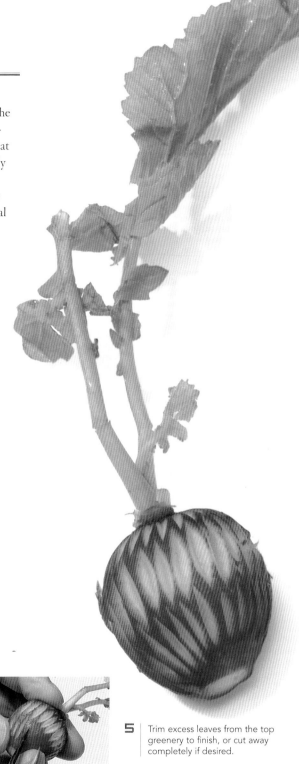

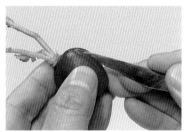

1 | Trim the bottom of a radish, then with a fine-edged knife or cutting instrument make a V-shaped cut in the center of the radish to create one facet of the mirror ball.

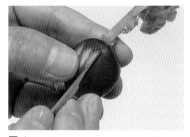

2 | Continue around the center of the radish until you have completed one row of cuts.

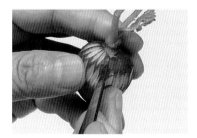

3 | Make a second row at the top of the radish.

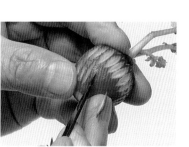

4 | Complete the cutting with a third row along the bottom.

5 | Trim excess leaves from the top greenery to finish, or cut away completely if desired.

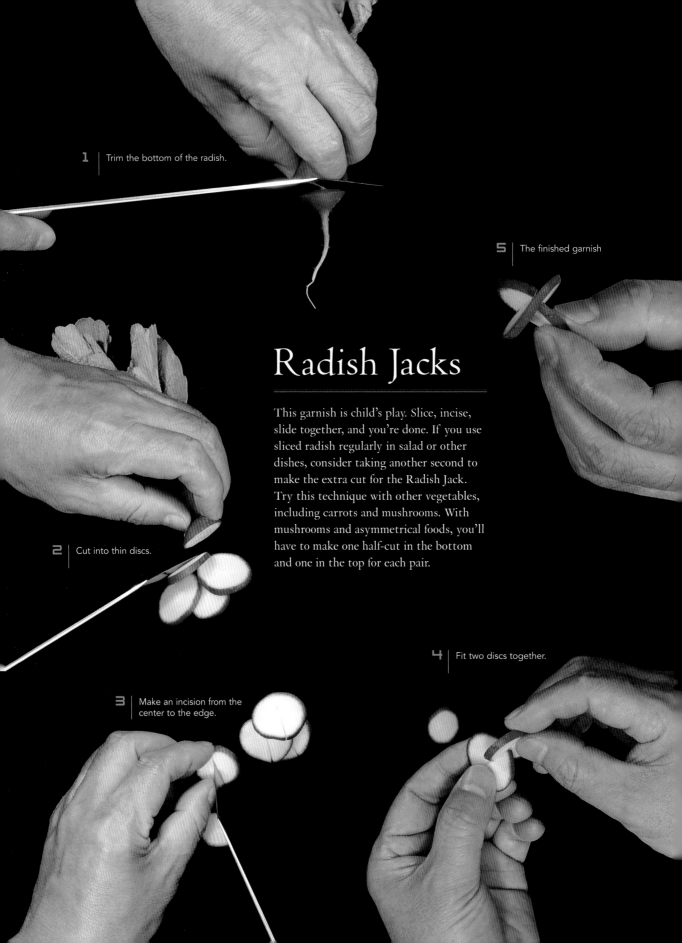

1 | Trim the bottom of the radish.

5 | The finished garnish

Radish Jacks

This garnish is child's play. Slice, incise, slide together, and you're done. If you use sliced radish regularly in salad or other dishes, consider taking another second to make the extra cut for the Radish Jack. Try this technique with other vegetables, including carrots and mushrooms. With mushrooms and asymmetrical foods, you'll have to make one half-cut in the bottom and one in the top for each pair.

2 | Cut into thin discs.

4 | Fit two discs together.

3 | Make an incision from the center to the edge.

Rosebud

The Rosebud is another charming radish garnish that rewards the attentive cook with great results for minimal effort. It is simple to make, and with scant practice you'll be able to whip up a whole bouquet in no time for an eye-catching culinary display for a salad, alongside a main dish, or sprinkled among a bowlful of veggies.

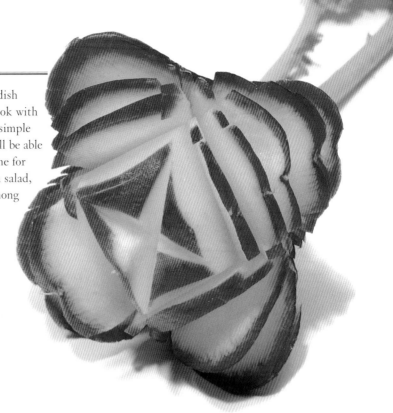

1 | Cut away a portion of the radish on all 4 sides as shown.

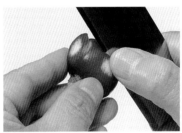

2 | Make a cut behind the trimmed portion to form a petal of the Rosebud. Leave room between each of the 4 sides for a second set of petals. Repeat with the remaining 3 sides.

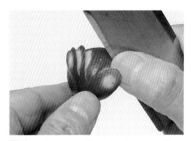

3 | Make cuts to form the first row of interior petals for all 4 sides.

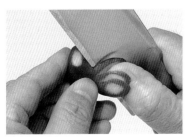

4 | Cut a third petal for all sides.

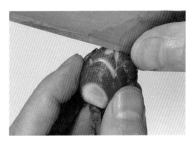

5 | Make two V-shaped cuts at the top of the Rosebud to form a cross.

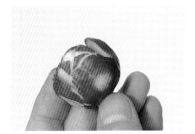

6 | Trim or remove the leafy greens at the base to finish.

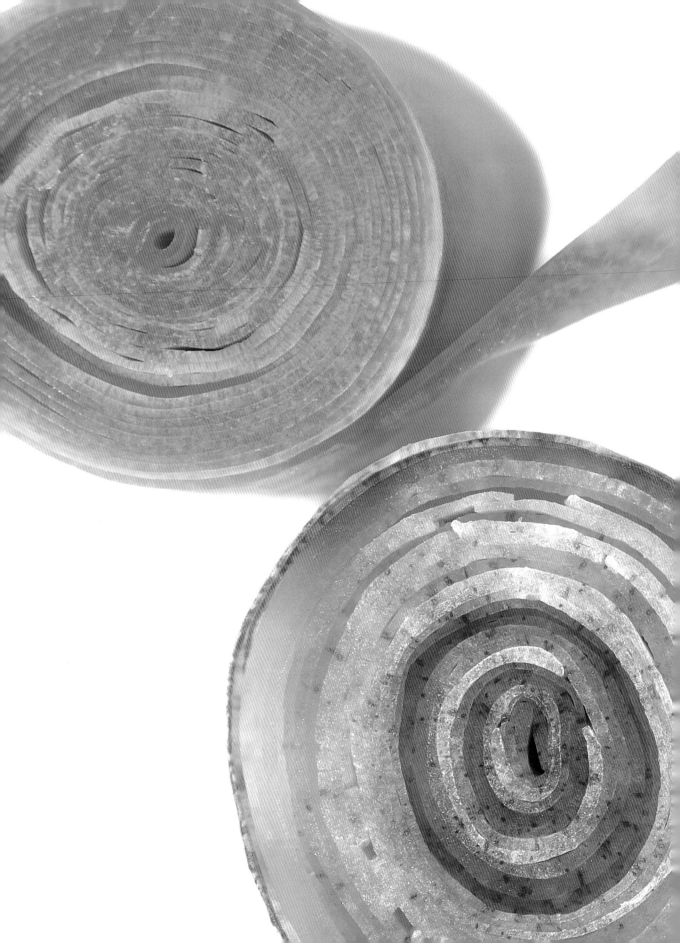

KATSURA-MUKI

A Traditional Japanese Pattern

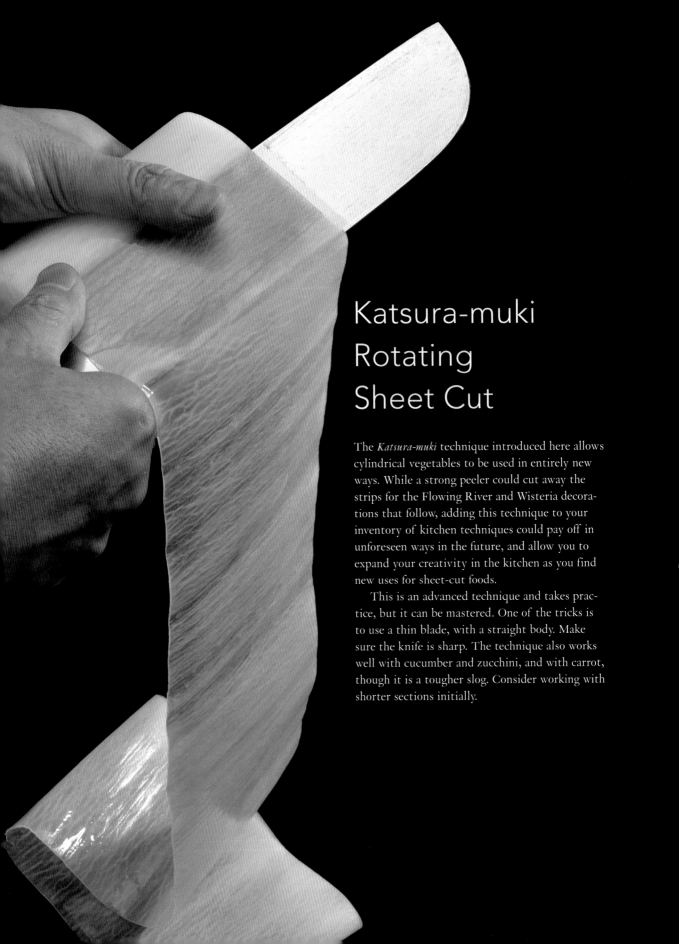

Katsura-muki Rotating Sheet Cut

The *Katsura-muki* technique introduced here allows cylindrical vegetables to be used in entirely new ways. While a strong peeler could cut away the strips for the Flowing River and Wisteria decorations that follow, adding this technique to your inventory of kitchen techniques could pay off in unforeseen ways in the future, and allow you to expand your creativity in the kitchen as you find new uses for sheet-cut foods.

This is an advanced technique and takes practice, but it can be mastered. One of the tricks is to use a thin blade, with a straight body. Make sure the knife is sharp. The technique also works well with cucumber and zucchini, and with carrot, though it is a tougher slog. Consider working with shorter sections initially.

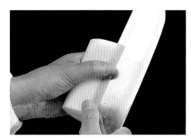

1 | Cut a 4- to 6-inch (10- to 15-cm) length from the widest part of a daikon radish. Hold the radish with your left hand and slide the edge of a sharp knife evenly into the daikon. While rotating the daikon, cut away the skin and tough outer portion. Discard and then slip the knife into the trimmed daikon . . .

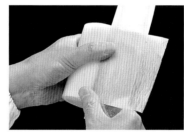

2 | . . . and while rotating the daikon with your left fingers and guiding it with your thumb, cut a thin, continuous sheet of daikon (about 1/16 inch/1 mm) by gently moving the knife up and down in a sawing motion. Move the blade up and back in 1/2-inch (1-cm) increments. The rotating should do most of the cutting. Work to find your own rhythm.

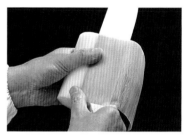

3 | The thumb of your left hand will slide over the blade. Pull it back, rotate, and continue to cut.

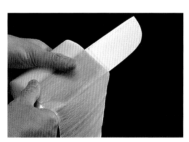

4 | Cut slowly and steadily.

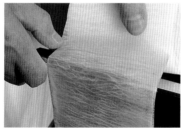

5 | With practice, you'll be able to cut a consistently thin, translucent sheet. Cut until the diameter of the daikon section is reduced to 1 inch (2.5 cm).

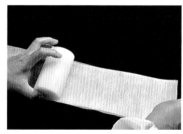

6 | Carefully role up the daikon sheet. Seal it in plastic wrap to prevent it from drying out.

NOTE: When thinly cut, a large daikon radish with a diameter of 4 inches (10 cm) will yield a daikon sheet of 16 to 22 yards (15 to 20 m)!

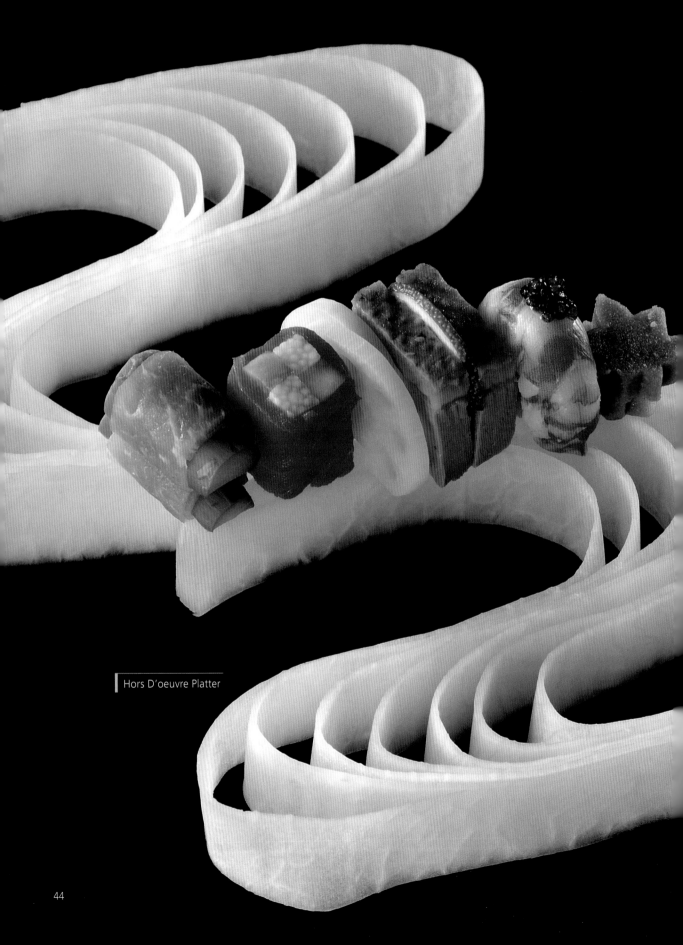

Hors D'oeuvre Platter

Flowing River

This Flowing River decoration works for individual settings and, by adding more waves, as a centerpiece. Use the waves as a foundation for a dazzling array of finger foods of your choice, mixing perennial favorites with seasonal specialties. For an extra flourish, serve one of the appetizers in a simple flower or leaf shape, but don't overdo it or you'll steal the Flowing River's thunder.

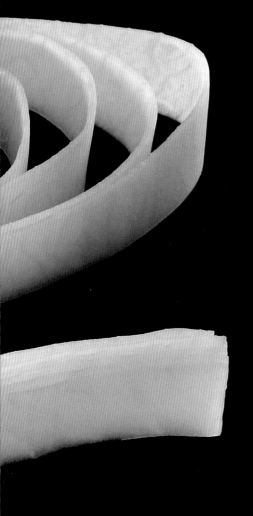

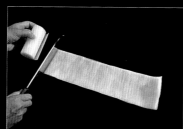

1 | Cut off a strip from a roll of daikon slightly longer than the dish or serving tray you plan to use.

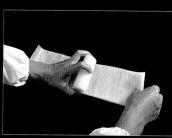

2 | Roll out the sheet over the severed strip and cut another of the same length. Repeat to make another pair.

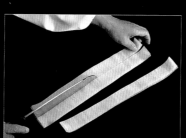

3 | Align sheets, trim edges, and cut in thirds lengthwise.

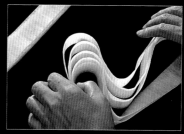

4 | Bend to form wave pattern.

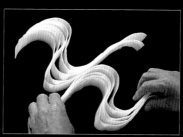

5 | Prod and adjust to form final shape.

NOTE: Rather than making the daikon roll introduced on the previous page, you could use a peeler to cut strips for the Flowing River. First, peel the radish, then slice off strips, and trim them so that each is the same length and width. Bend to form wave pattern as shown in step 4. Be sure and use a sturdy, quality peeler with a sharp edge and a wide enough gape.

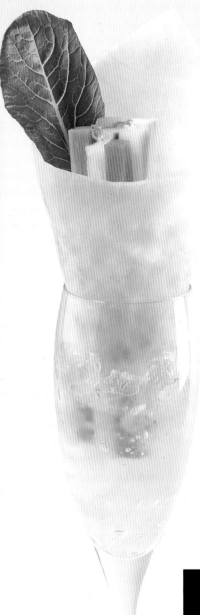

White Lily

This garnish evokes an immediate sense of elegance when set in a tall flute glass, which also serves to maintain the flower's shape. Consider other appetizers or a small scoop of, say, crab salad. A well-chosen, well-washed leaf completes the image.

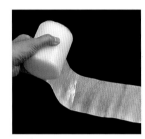

1 | Roll out a strip of daikon.

2 | Roll up one side . . .

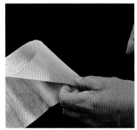

3 | . . . to form the Lily. The second layer should stop at the back of the flower.

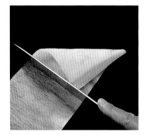

4 | Cut flower from the strip.

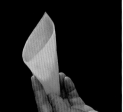

5 | The shape should look like this. Repeat and make as many flowers as you need.

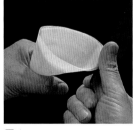

6 | Run the edge of a knife under the top point to pull out the lip of the flower and finish the shape.

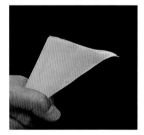

7 | The finished form.

Vegetable and Cheese Sticks

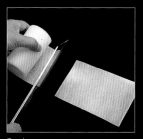

1 | Cut off a strip from the daikon roll.

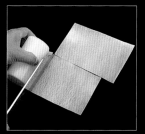

2 | Cut a second, slightly shorter sheet. For each Wisteria stock you will need 4 or 5 2-sheet sets.

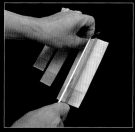

3 | Place the shorter sheet over the longer, then cut lengthwise into quarters.

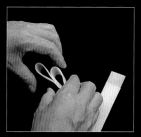

4 | Make a loop with each 2-ply strip.

Wisteria

As with the Flowing River arrangement on page 44, this piece works for individual servings or as a centerpiece. For the latter, you could easily add a third or fourth stalk of flowers and offer up several more servings on daikon or carrot pedestals, or in small porcelain cups. Taking in the opulence of the display, the diner expects a true delicacy, and here the selection of sashimi, fresh slices of raw seafood, do not disappoint.

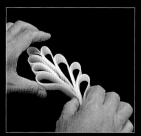

5 | Adjust the size of the loops as you go.

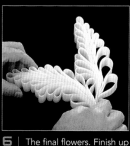

6 | The final flowers. Finish up with a parboiled string of green vegetable, or a thin sprig of celery. Five sheets were used for the bottom stock, 4 for the top.

NOTE: A peeler can also be used to cut away strips from the daikon. Just remove the peel, then slice off strips, and trim so each is the same width. Match shorter strips to longer ones, and proceed to step 4. Again, be sure and use a sturdy, quality peeler with a sharp edge and a wide enough gape.

| Sashimi Select

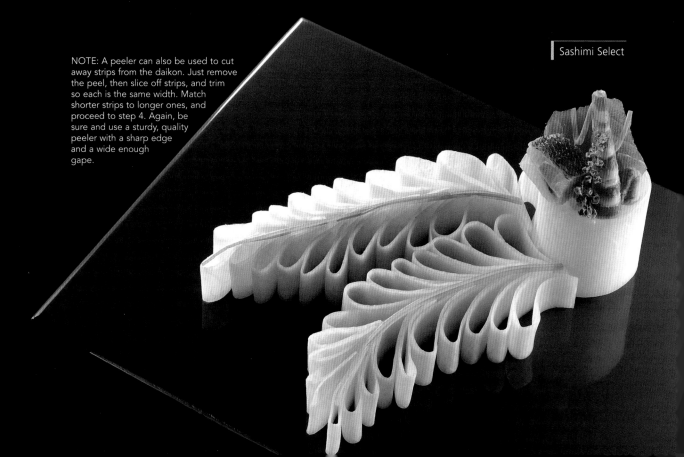

Morning Glory

With a push, a few snips, and a sprig of greenery, these rolled vegetable cups are transformed into the very image of a Morning Glory. Add a platter or more decorative accessory and you have a stunning table setting, or with more flowers, a charming centerpiece. A variation of this garnish appears on page 13 minus the final snips to delineate the petals of the flower.

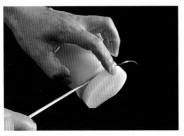

1 | From a tightly rolled daikon sheet (page 43) cut off a ½-inch-thick (1.3-cm) round.

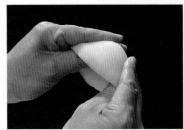

2 | Push out gently at the center, being careful to spread the layers evenly . . .

3 | . . . to make the Morning Glory base.

4 | Make four shallow cuts at the lip to complete a pentagonal flower.

5 | The finished flower.

Papaya and Salmon Roll, Asparagus and Prosciutto Roll, Tuna Sashimi and Japanese Long Onions

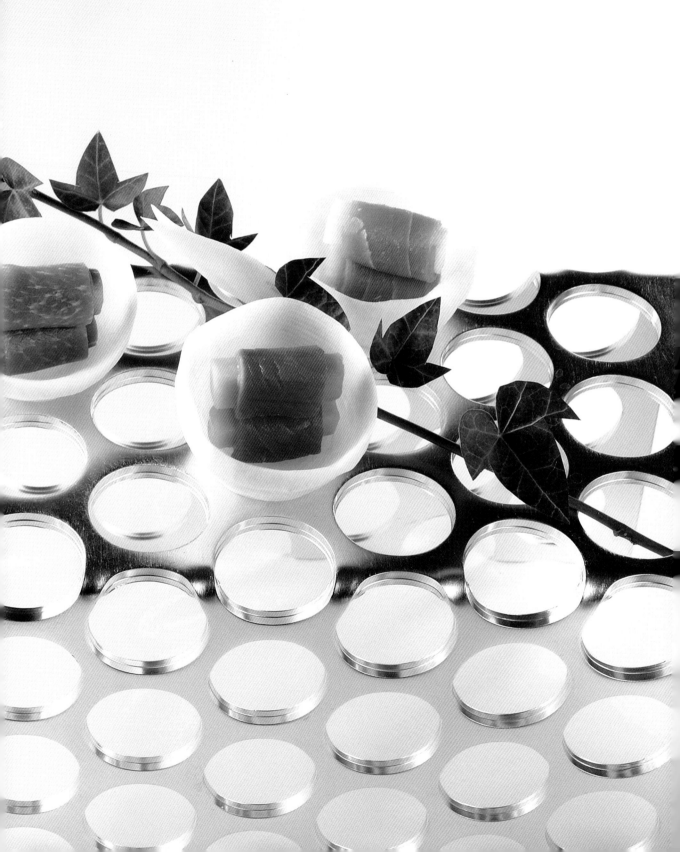

Zucchini Boat
with Paddle

The Zucchini Boat is another example of a food garnish that is made with little effort but delights with its seeming complexity. Add colorful "passengers," as is done here, and the Boat comes to life. The fun—and cook's challenge—is in finding an appropriate paddle for the food of his or her choice.

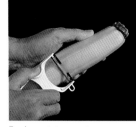

1 | Peel the zucchini.

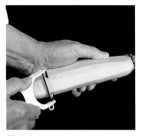

2 | Cut it into long strips.

| Sushi Balls with Sprig of Ginger

3 | Stack and . . .

4 | . . . trim the top and bottom.

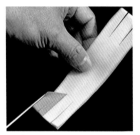

5 | Cut the top and bottom into thirds as shown.

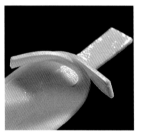

6 | Cross two outside strips. Repeat on the other end.

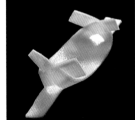

7 | The finished Boat.

Zucchini Rolls

Here the Zucchini Rolls provide an edible decorative base for tasty morsels of beef, but of course the idea lends itself to numerous possibilities. An ongoing theme in these pages is to combine a succulent morsel of food with something simple yet substantial such as zucchini. Use your imagination to provide additional toppings, or to supplant the zucchini with a new vegetable.

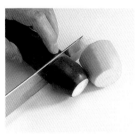

1 | Trim ends of the zucchini then cut into 1-inch-thick (2.5 cm) discs.

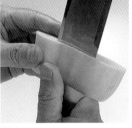

2 | Cut to make swirling pattern.

| Prime Rib Cubes over Sautéed Zucchini

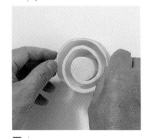

3 | Sauté or serve raw.

The Fish Net allows you to capture and roll up a delicate, tender portion of food with a layer of vegetable for a decorate effect that is reminiscent of *nori*-wrapped sushi rolls. True to the fish theme, the two rolls here are stuffed with Salmon Mousse and a soft, grilled sole. Rolls can be stuffed with other foods of course, or the Fish Net can be laid flat with food set on top of it. For neat rolling, use a bamboo sushi mat or a damp cloth that will not stick.

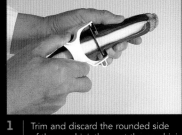

1 | Trim and discard the rounded side of the zucchini, then cut the zucchini into strips.

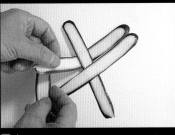

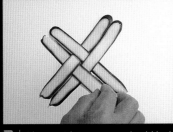

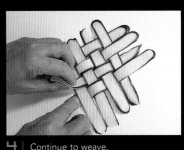

2 | Parboil strips in salted water (1 tbsp to 1 cup/240 ml water) for 10 to 15 seconds, cool, and weave together.

3 | The garnish-in-progress should look like this after the fourth strip.

4 | Continue to weave.

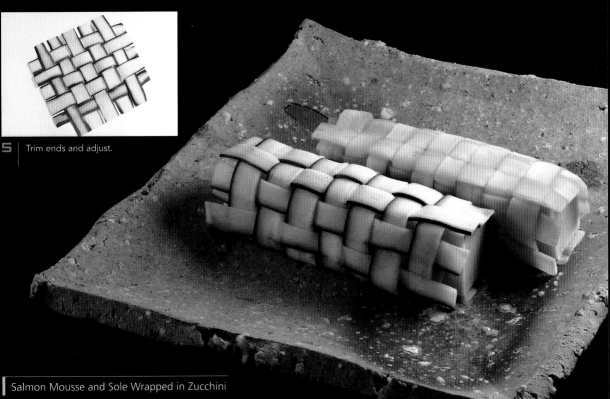

5 | Trim ends and adjust.

Salmon Mousse and Sole Wrapped in Zucchini

CUTOUTS

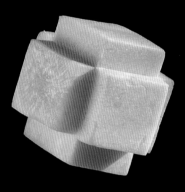

Square Cuts

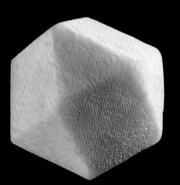

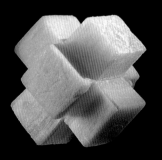

Diamonds in
the Rough

Two rough-cut vegetable Diamonds, each seasoned in a chicken broth, decorate this succulent pork dish. Simple, playful, and edible, these geometric garnishes lend themselves to endless variations, whether cooked or raw. Consider other vegetable combinations. Have a child who shuns healthy foods? Carve up some carrots and other veggies, season them in a child-friendly manner, and you may turn a vegetable hater into a vegetable lover.

1 Peel a carrot and trim the ends.

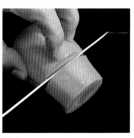

2 Cut off a 1-inch (2.5-cm) block.

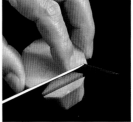

3 Lay flat, then begin trimming sides to make a cube.

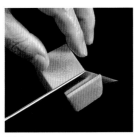

4 Cut the fourth side to finish the cube and . . .

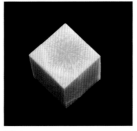

5 . . . trim to clean up the shape if necessary.

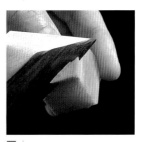

6 The basic cube shape.

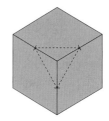

7 Cut off a corner as shown.

The corner should be cut to the halfway point along all 3 edges.

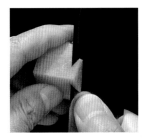

8 Cut the remaining 7 corners.

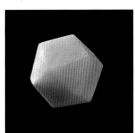

9 The finished Diamond.

| Steamed Pork with Mustard Sauce

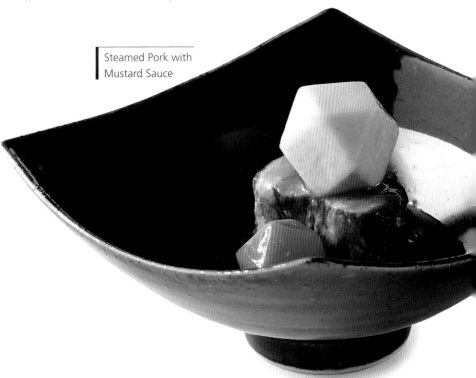

Rolling Dice

It is hard to do much with a soft-bodied pâté until it reaches the diner's palate, so the Rolling Dice garnish draws the eye's attention, creating depth and movement. This playful, abstract geometric decoration lends itself to a number of presentation styles. In more modest numbers, Rolling Dice veggies will delight children. Here, in a unique yet formal dining setting, they offer up full portions of carrot and daikon alongside the pâté, and provide drama and grandeur for the occasion.

1 Begin with a basic 1-inch (2.5-cm) cube shape, following steps 1 to 6 on page 55. Start by making a cut ⅛ inch (3 mm) from the edge, gripping the knife with your index finger extended to guide your cuts and prevent you from cutting too deeply.

2 You are going to cut 4 notches from opposite sides of the cube to make the shape. Straighten the knife to finish the cut begun in step 1.

3 Continue to cut notches.

4 The finished garnish.

5 For a more abstract effect, add the detailed fringe cuts.

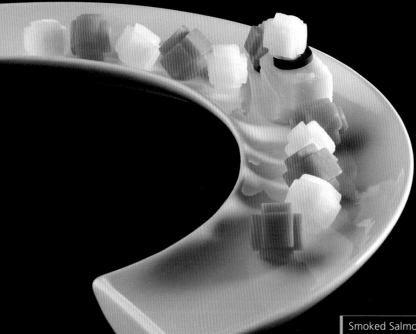

Smoked Salmon Pâté with Vegetables

Pinwheel

The shape of a classic children's toy becomes a decorative garnish in seconds here, and is sure to delight children of all ages. Made from a pink daikon radish, its charm might even coerce a child to try some of your more healthy vegetable dishes. It's worth a shot! Works well with a standard white daikon or large turnip.

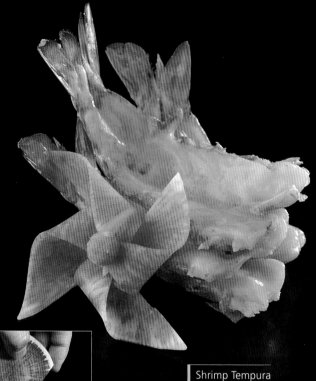

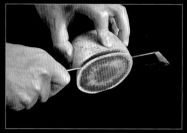

1 | Cut a thin slice (about 1/16 inch/2–3 cm) from a daikon.

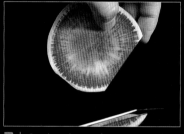

2 | Cut the edges to form a square, but do not cut off too much.

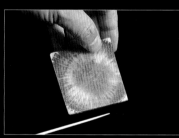

3 | Once you have a nice square about 2½ inches (6 cm) on each side . . .

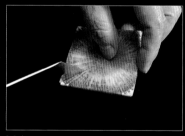

4 | . . . make a ¾-inch (2-cm) cut in each corner. Soak in lightly salted water (1 tbsp to 1 cup/240ml water) for 1 to 2 minutes.

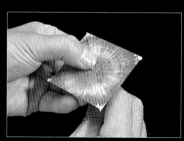

5 | Pass a skewer through the center and . . .

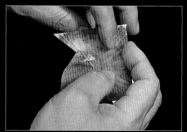

6 | . . . fold over a corner and pierce with the skewer.

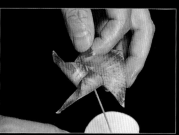

7 | Repeat with remaining 3 corners.

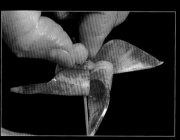

8 | Cover the end of the skewer with a decorative piece of vegetable (here, a small carrot pellet), if desired.

57

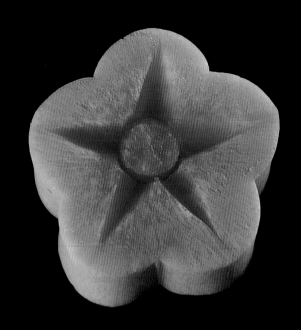

Pentagonal Cuts

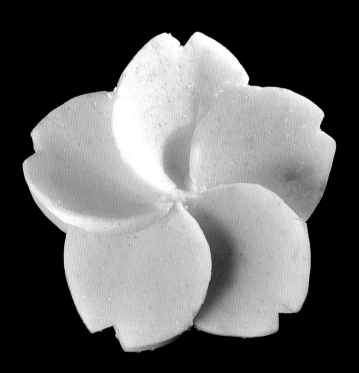

Making a Pentagon Shape

The next eight garnishes use the pentagon as a launching pad. With very little practice, you'll be able to master the basic steps outlined here. Use the simple-to-make paper guide because it turns an extremely difficult task into a foolproof one. (Cutting a perfect pentagon freehand is harder than you might think!) If you don't have time to make one of the garnishes in this section, consider shaving off slices from the pentagon and arranging them on or around the food.

1 | First take a strip of paper and . . .

2 | . . . bring around one end to make a loop.

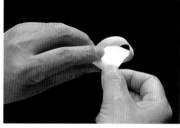

3 | Pass one end through the loop.

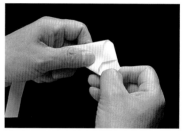

4 | Pull tight until all of the paper passes through the loop and flatten.

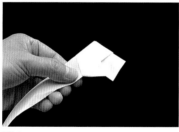

5 | Your paper model should look like this.

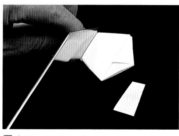

6 | Trim both ends of paper to make pentagon.

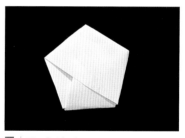

7 | The finished pentagon.

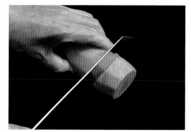

1 | Cut a section from the food you are using.

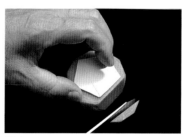

2 | Place the paper pentagon on top and trim the sides to make a pentagon.

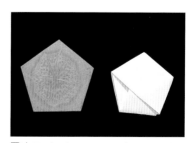

3 | Finished pentagon and paper guide.

Plum Blossom

Here, a large cluster of Plum Blossoms were carved from a daikon radish then parboiled in a chicken broth and topped with flavored egg yolk. The blossoms offer an enchanting way to present cooked vegetables, whether daikon, turnip, potato, sweet potato, or fresh bamboo shoots, to name just a few. If you find the idea appealing, consider investing in a sturdy cookie cutter or Japanese food cutter (see Tool section) to speed up the process.

| Daikon Plum Blossoms Seasoned in a Chicken Broth

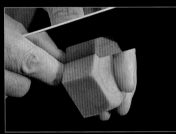

1 | Beginning with a pentagon shape, make a ¼-inch-deep (½-cm) incision in the middle of one side. Press your index finger against the knife to guide the edge of the knife and avoid cutting too deeply.

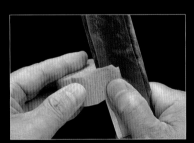

2 | Then from a corner make a diagonal curving cut to the bottom of the incision to form one side of a petal blossom, cutting away a triangular wedge from the pentagon.

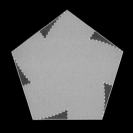

Make incision in the center of each side, then cut from the corner back to the incision.

3 | After five cuts, the pentagon will look like this.

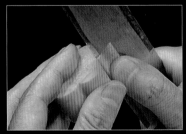

4 | Turn the pentagon over and make the same cut from corner to center on the remaining uncut portions. Trim the petals as necessary.

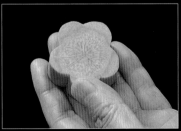

5 | The finished Plum Blossom. Cook and scoop out the center to add a filling.

Plum Blossom

You'll have no complaints if you serve this rich-tasting dish decorated in this manner. The Plum Blossom shape underscores the preciousness of the brandied carrots themselves. Slice the blossoms thinner, parboil, and sprinkle over a salad for an entirely different effect.

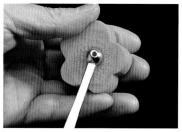

1 Make the plum blossom shape on the facing page, then with any round tool at your disposal . . .

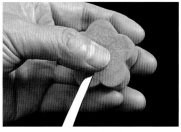

2 . . . inscribe a small circle in the center by pressing down or drawing a circle.

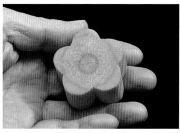

3 Your plum-blossom-in-progress should look like this.

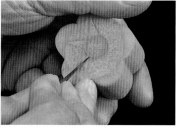

4 With the fine point of a knife or pick, inscribe the five points. Each should point to the center of a petal.

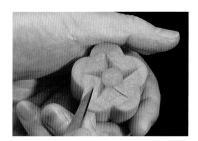

5 Carve out the triangles.

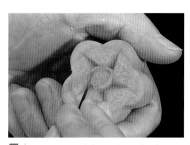

6 Carve around the circle to finish.

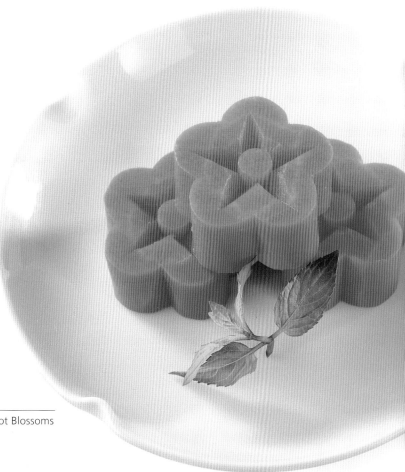

Brandied Carrot Blossoms

Fluttering Plum Blossoms

Looking at this garnish, you can easily imagine plum blossoms fluttering in the wind, or falling—in a gentle swirling motion—to the ground. The thinly sliced carrot and daikon along with tender morsels of prosciutto are tossed in an oil and vinegar dressing. Scatter Plum Blossoms over your favorite salad, or arrange a cluster of three as a garnish for your main dish.

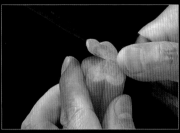

1 | Make the basic plum blossom shape (page 61) using a long section of carrot or vegetable of your choice, then make a make a diagonal cut into the plum blossom while rotating the vegetable.

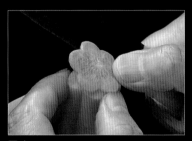

2 | Continue to rotate as you cut . . .

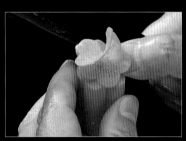

3 | . . . until you have cut a little more than two rotations. Cut off the plum blossom. Soak in water for at least 2 minutes.

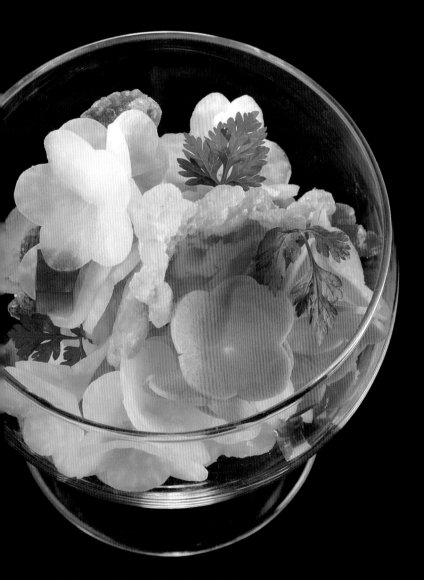

Carrot and Daikon Salad with Prosciutto

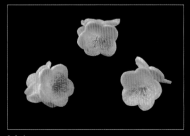

4 | Finished blossoms.

Chinese Bellflower

The Chinese Bellflower carving offers an imaginative way to present an old favorite—baked sweet potato. Serve it stacked two together as shown, or in a pyramid of three. If you wish to take it one step further, hollow out the center with a small cookie-cutter shape and fill with a topping of your choice—honey, mousse, jam, or fresh crushed berries.

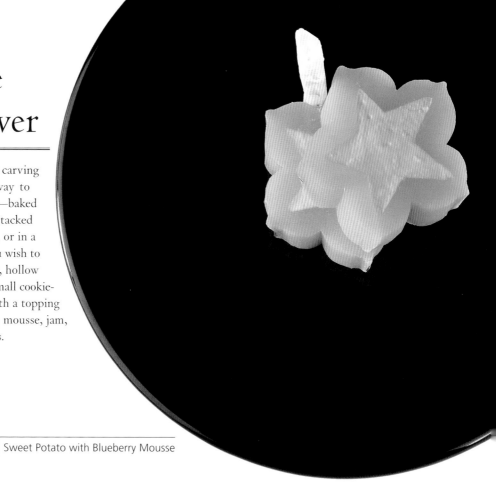

Sweet Potato with Blueberry Mousse

1 | Cut off a section of potato.

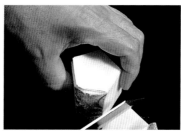

2 | Make a paper pentagon (page 59) then cut the potato into a pentagonal shape.

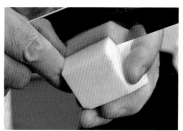

3 | As was done for the plum blossom on page 60, make an incision at the halfway point, this time ⅛ inch (3 mm) deep.

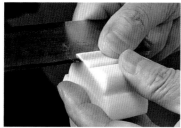

4 | Then from the corner cut back to the incision, making half of the petal shape. Repeat with the other 5 sides, then turn over and make other half of each petal.

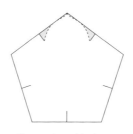

Cut petals to this shape.

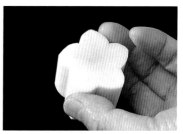

5 | The finished Bellflower. Cook with care so as not to distort the shape.

Two-Ply Cherry Blossom

Used properly, this garnish is a showstopper. Here, boiled shrimp alternates with sautéed scallop, smoked salmon, and fresh kiwi for an eye-opening display. This is only one of countless combinations. Stack bite-size pieces of your favorite foods between the blossoms. Select food for its hue as well as its taste. The white of the blossoms allows for a wide color palette.

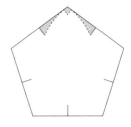

Cut petals to this shape, making the notch in step 2 after all the petals have been formed.

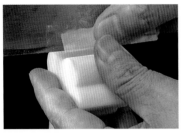

1 | Make the pentagon shape on page 59, then make a ⅛-inch-deep (3-mm) incision in the middle of a side. From the corner cut to the bottom of the incision with a curving motion. Repeat on the 4 remaining sides. Turn the carving over and repeat to finish petals.

2 | Make a shallow notch in each petal.

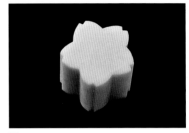

3 | This is the basic cherry blossom shape. Make a thin cut across the face of the blossom about ⅛ inch (3 mm) thick, but do not cut all the way through. Make a second cut at the ¼ inch (6 mm) mark to finish the blossom and the second layer.

NOTE: Refer to the plum blossom shape on page 60 for the general cutting principles behind this garnish.

Carved Cherry Blossom

Carve and cook the potato, stack it attractively, and add a second food as is done here, or simply serve the potato alongside the main course, whether meat, fish, poultry, or a vegetarian dish. Substitute carrot, daikon, or any fibrous vegetable. Master this garnish and it will add a charming touch to any meal.

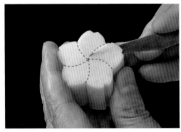

1 | Carve out the basic cherry blossom shape, then make a shallow incision and cut along the face of one petal to a depth of ⅛ inch (3 mm) to the edge of the next petal, slowly bringing the blade back to the surface.

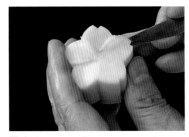

2 | Continue with remaining petals.

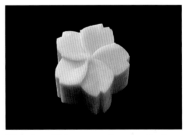

3 | Cut off blossom and repeat. Cook to taste.

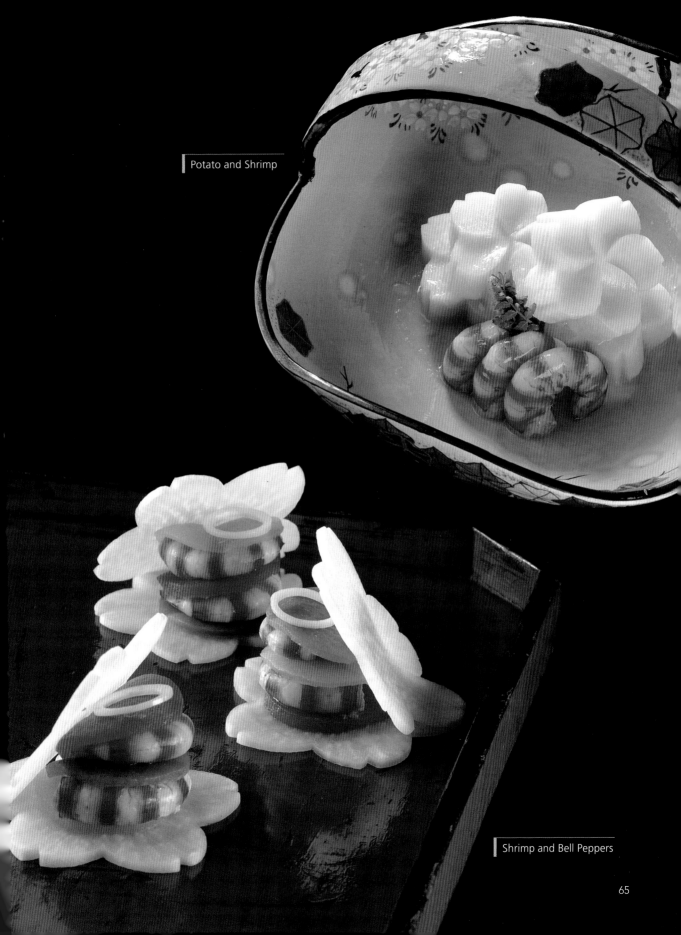

Potato and Shrimp

Shrimp and Bell Peppers

Moon and Star

Here, the Japanese pudding introduced in its standard form in the Recipe Notes for page 84 completes this poetic imagery. The star is made from yellow zucchini, the natural curve of the vegetable adding a tenderness to the scene. Serve on standard tableware and this combination works for adults, on a festive child's plate (paper, plastic, or china) and it will give a party or a meal a touch of fairy tale magic.

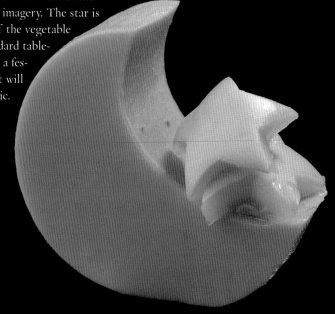

Japanese Pumpkin Pudding

1 From the pentagon shape (page 59), make a ¼-inch (6-mm) incision into in the center of one side, again using your index finger to guide and control the knife.

2 From the corner, cut to the bottom of the incision to form one side of the first point.

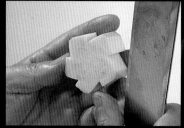

3 Repeat with the remaining sides. The garnish-in-progress should look like this.

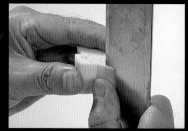

4 Turn it over and carve the other half of all 5 points. Trim points to make them even.

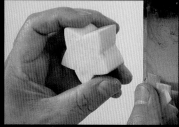

5 The finished star. Cook to taste, if desired. For guidance on the moon shape, see the Recipe Notes.

NOTE | Refer to the plum blossom shape on page 60 for the general cutting principles behind this garnish.

Shooting Star

This is a charming way to elevate and freshen up this old standard. The Shooting Star is easily made and, here, lends a homey yet inventive charm to the classic steak dinner. The garnish has a dreamy quality, and for some at your table it will allow the imagination to soar. For the rest it should at least elicit a smile! Use with anything that seems appropriate, including a salad, vegetable dish, or dessert, in which case be sure to refer to the Glacé recipe in the Recipe Notes for page 73.

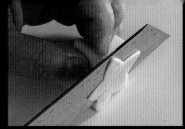

1 | Make the star shape on the facing page, using a 1½-inch (4-cm) length of zucchini, carrot, or vegetable of your choice, then slice nearly all the way through, leaving a portion of one corner of the star uncut.

Slice thinly, leaving the tip of the same corner intact each time.

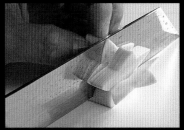

2 | Make about 15 cuts down the length of the vegetable. Again, cut thinly.

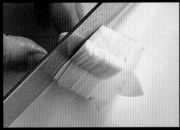

3 | Continue cutting to the end, or trim away the excess.

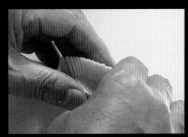

4 | Gently spread and shape.

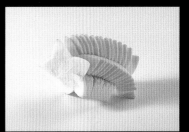

5 | The completed Shooting Star.

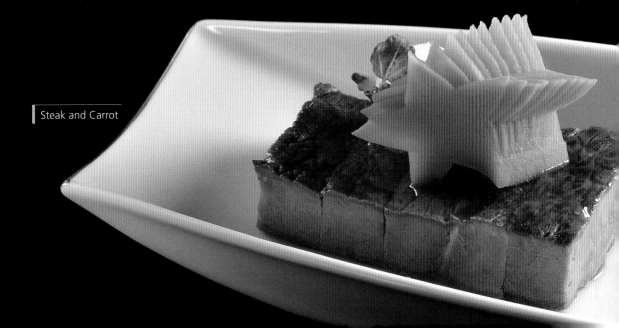

Steak and Carrot

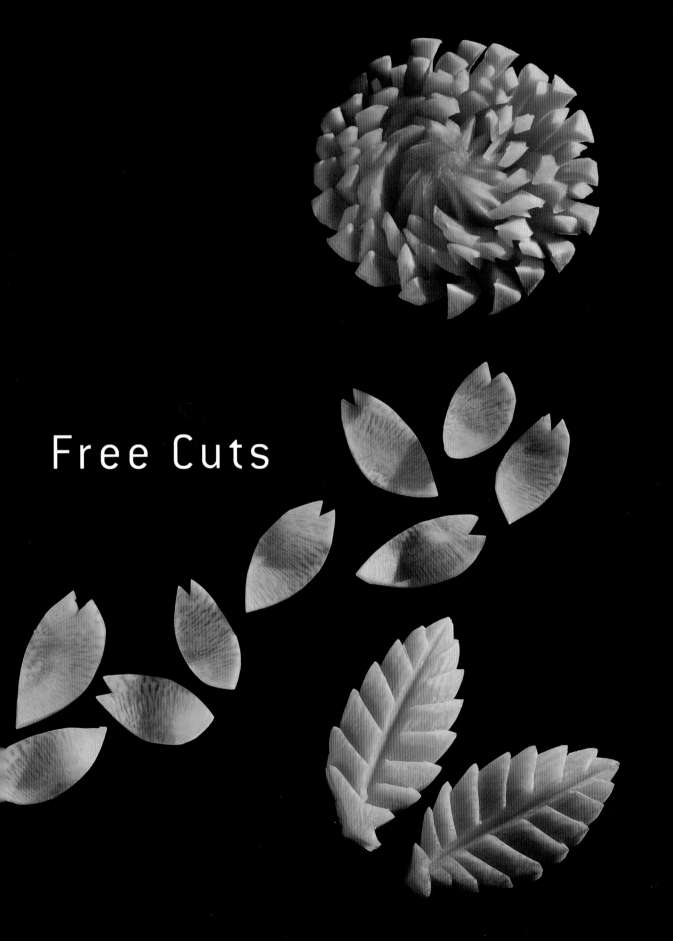

Free Cuts

Carved Leaf Cluster

As an opening salvo to a dinner that will delight the palate and the eye, Carved Leaf Clusters also find service as a garnish for salads, such hot dishes as spaghetti, or even a steak-and-baked-potato combination plate. Add green and yellow squash or other vegetables and the leaf cluster motif poetically recalls autumn's change of colors.

1 | Cut a ½-inch-thick (1.3-mm) disc from a peeled carrot, then cut the disc in half and carve out the basic leaf shape.

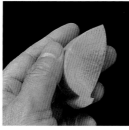

2 | The rough-cut leaf.

Carve a basic leaf shape from a half-moon shape. Start with the incision for the stem, and from the *top* make a curved cut to meet the bottom of the incision.

Make 2 notches on the other side to finish the leaf shape, rounding out the straight edge in between if desired.

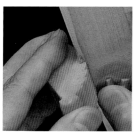

3 | Make the zigzag edge on both sides of the leaf.

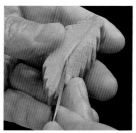

4 | Use a thin knife or utensil to make a line down the center from stem to tip.

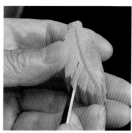

5 | Make shallow incisions along the top, following the zigzag cuts at the side.

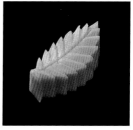

6 | The finished leaf. Cook to taste.

Lightly Vinegared Carrot

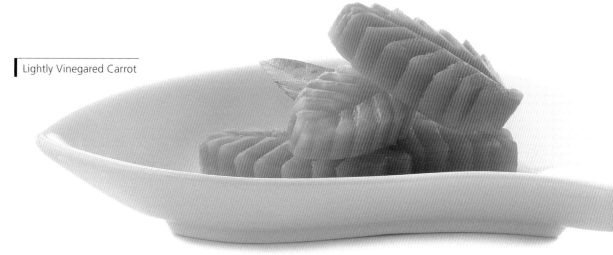

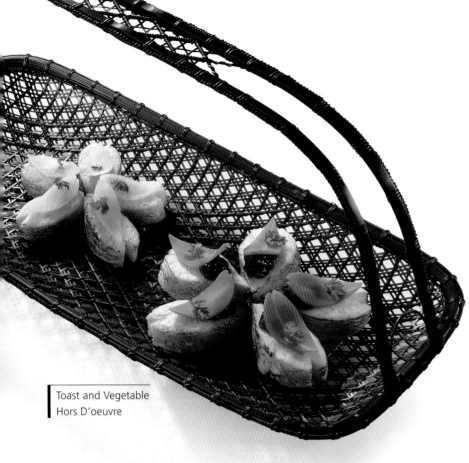

Toast and Vegetable
Hors D'oeuvre

1 | Cut off a disc of daikon and carrot, peel, and then cut in half.

2 | Cut both sides to form an oblong petal shape as shown.

Five-Petalled Cherry Blossom

Surprisingly easily to make, this cherry blossom pattern works well for single place settings, or as a group serving on a large platter. Each flower was cut from one piece of thickly sliced bread. For a six-petalled design, make slimmer petals.

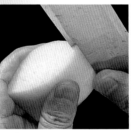

3 | Notch the top of the petal.

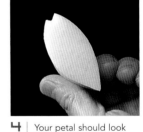

4 | Your petal should look like this.

5 | Cut a paper-thin slice about 1/16 inch (1–2 mm) thick.

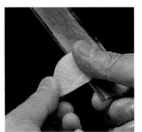

6 | Run along the edge of a knife to curl, pressing lightly with your thumb. Soak in water. While the vegetables are soaking, cut the bread into larger petals, following the shape in step 4.

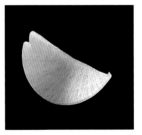

7 | A finished petal.

Sliced Leaf Cluster

The light, airy feeling of this garnish wonderfully complements light foods such as this gelatin dessert. The Leaf Cluster's feathery elegance has many applications. It makes a chic yet tasteful addition to nearly any main course, for one. Try using carrot, turnip, or other vegetables.

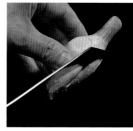

1 Trim the sides and the bottom of a ginger stalk (or the vegetable of your choice), making sure you leave enough at the bottom for the leaf stem.

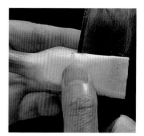

2 Flatten to block out rough leaf shape.

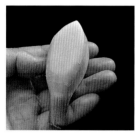

3 Your basic shape should look like this.

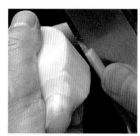

4 Notch a zigzag on both sides of the leaf as is done on page 69.

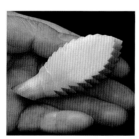

5 This is the final leaf shape.

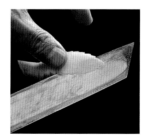

6 Slice thinly down to the bottom of the leaf without cutting into the stem.

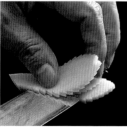

7 Repeat several more times.

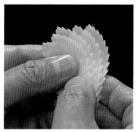

8 Spread and press to make final shape.

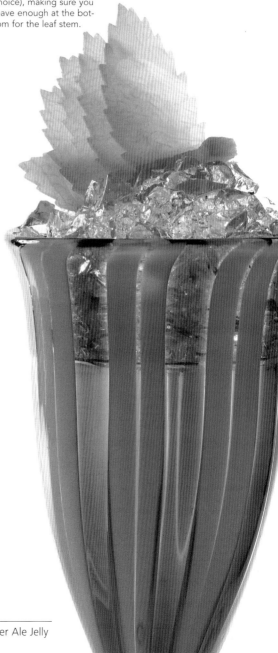

Zesty Ginger Ale Jelly

Pine Needle Cluster

This garnish, cut here from a raw zucchini, is reminiscent of a cluster of pine needles to some, of a leaping dolphin to others. Whichever image it may conjur up for you, the garnish itself takes but seconds to make yet suggests consummate culinary skill. While the pliancy of zucchini adds a touch of challenge, using stiffer vegetables such as carrots or cucumber will make this even easier.

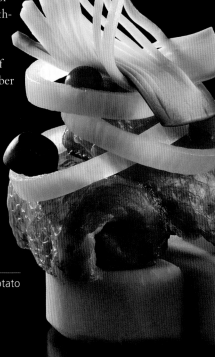

Smoked Fish and Potato

1 Cut a 4-inch (10-cm) length about ¼ inch (6 mm) thick. Make a series of parallel cuts from top to the bottom, leaving ½ inch (1.3 cm) uncut at the base.

2 From the bottom slice in half, leaving about ¼ inch (6 mm) uncut at the top.

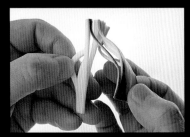

3 Pull apart and . . .

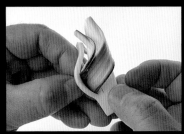

4 . . . slide one end through a slit of the other half.

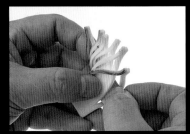

5 Bring uncut ends together and spread needles to make final shape. Soak in water.

Chrysanthemum

Another elegant garnish, the Carrot Chrysanthemum works wonderfully well as a garnish for a meat or fowl dish and does double duty as the vegetable for the meal. The secret to creating the petals is simply to move a half stroke over so that the open end of the V or U faces the "valley" of the previous row as shown in step 2. Season the carrot to taste, or glaze, as is done here.

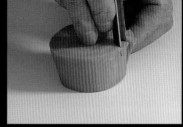

1 | A V-shaped food-carving chisel is used for this flower, though a U-shaped tool will also work. Cut a round, wedge-shaped slab from a peeled carrot as shown, *set aside for 4 or 5 hours*, then begin making incisions into the flower, leaving about ¼ inch (6 mm) uncut at the bottom.

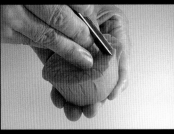

2 | Cut around the outer edge first.

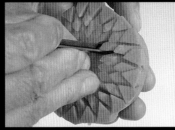

3 | Shift half a cut over for the second row, which will give you a rough diamond shape after the second cut when the two Vs touch. Continue cutting until you have cut circles to the center. Soak in fresh water for 5 minutes.

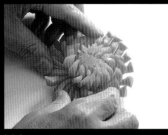

4 | Gently spread petals to finish flower.

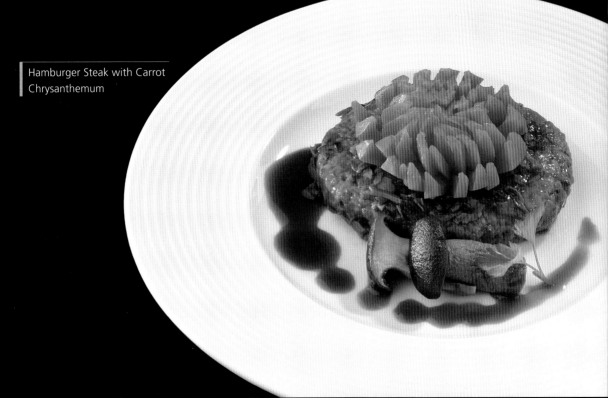

Hamburger Steak with Carrot Chrysanthemum

Cookie-Cutter Pattern:
Cherry Blossom

Cookie cutters can work magic in a few seconds. Look for more adult themes, like the Cherry Blossom in the daikon dish here or the Snowflake pattern in step 2. No matter what cookie-cutter pattern you choose, the key is to find an attractive shape. For raw vegetables—carrot, zucchini, and such—make sure you choose a strong cutter with a sharp edge. Quality kitchen cutters, or the Japanese cookie cutters shown here and in the Tool section at the back of the book, can cut through thicker slabs of vegetable. For thinner cookie cutters, consider parboiling and seasoning your food before cutting. For an additional flourish, top your food with small garnishes, such as the variation of the Carved Leaf Cluster (page 69) or the Carved Cherry Blossom (page 64).

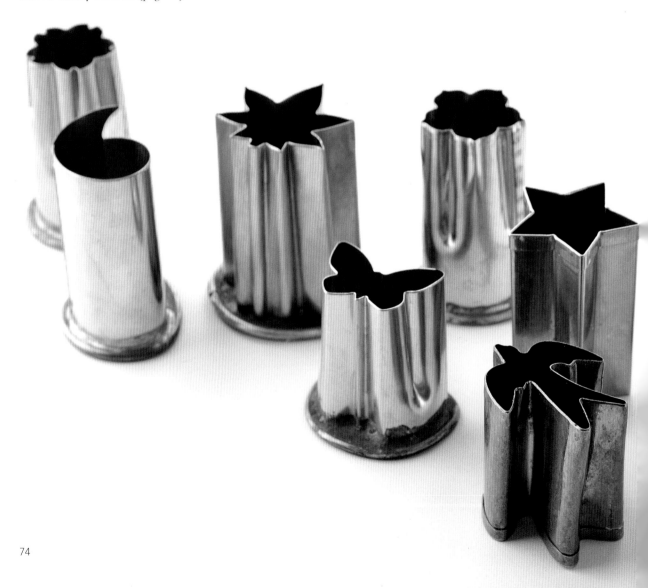

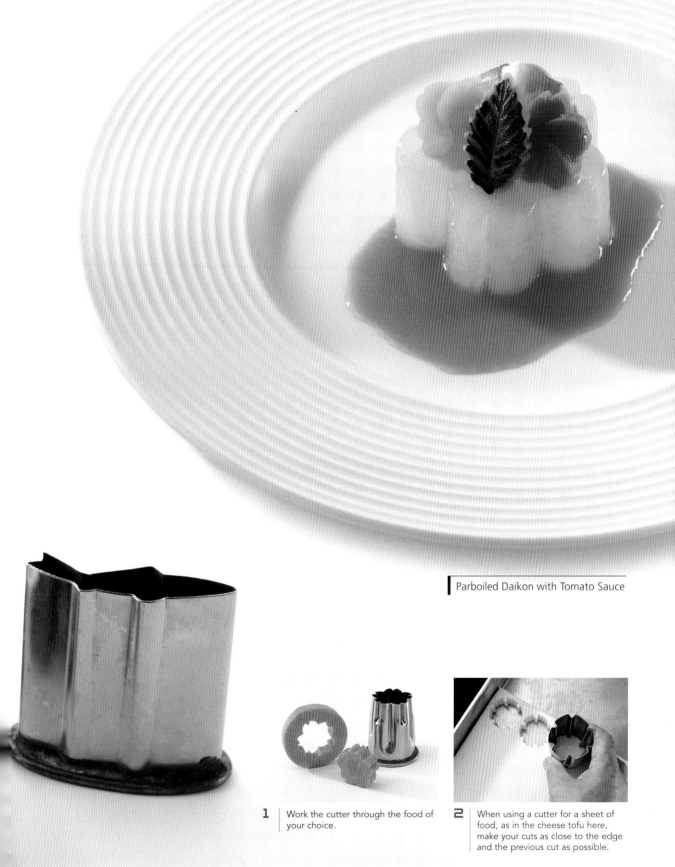

Parboiled Daikon with Tomato Sauce

1 | Work the cutter through the food of your choice.

2 | When using a cutter for a sheet of food, as in the cheese tofu here, make your cuts as close to the edge and the previous cut as possible.

Eggplant Fancy

Lily

This eggplant appetizer is carved in the form of a lily and then deep-fried, resulting in a charming appetizer for any occasion. Here, the Lily is filled with a hollandaise sauce and eaten as is, but consider stuffing it with a favorite delicacy—say, baby shrimp topped with a dab of cocktail sauce, or salmon roe (*ikura*) from your local fish monger.

Eggplant and Hollandaise Sauce

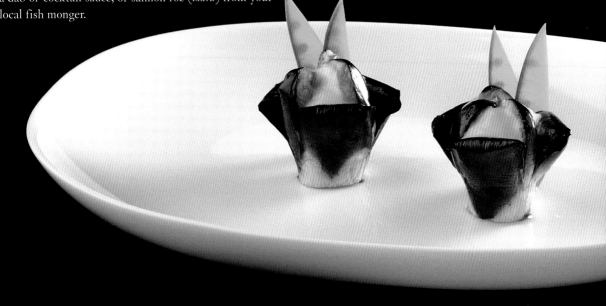

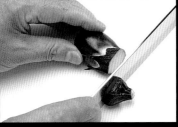

1 | Trim the end of an eggplant.

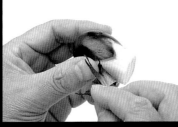

2 | Remove a portion of the peel from what will become the base of the Lily.

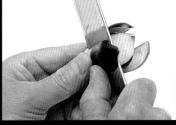

3 | Make 3 cuts to form a triangle and the first 3 of 6 flower petals. Leave space between the cuts to form the next 3 petals.

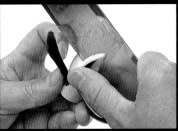

4 | Cut the next 3 petals and . . .

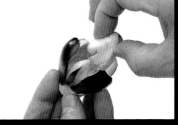

5 | . . . remove the center section.

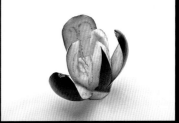

6 | The finished Lily.

Fish Trap

If you love stuffed eggplant, here's a new way to present it. The eggplant entwines the food, giving the diner a peek at what is to come. Inspired by the traditional river traps of old that were fashioned from tubes of giant bamboo, the Fish Trap garnish becomes a major element of the dish itself. Use small eggplants and you have an attractive appetizer, larger ones and you're all set for your main course. Consider stuffing with shrimp balls, a vegetable-and-tofu mixture, diced cubes of meatloaf, or just about anything that comes to mind. Bake or deep-fry, depending on your preferences and choice of stuffing.

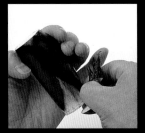

1 | Trim both ends of an eggplant.

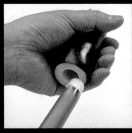

2 | Hollow out the center with a punch or an apple corer.

3 | After the core is removed . . .

4 | . . . make vents in the side of the eggplant and cook.

Stuffed Eggplant

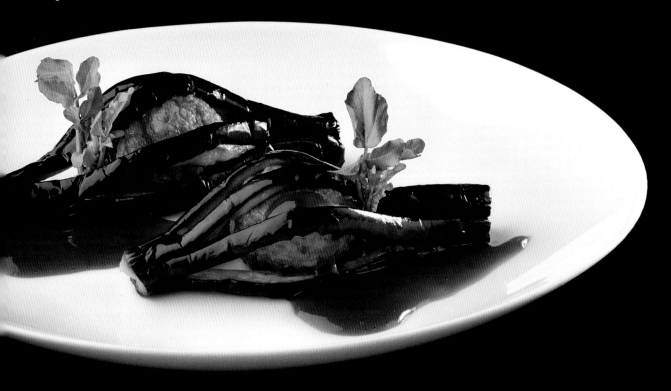

Chrysanthemum

Making this decorative eggplant "garnish" is simplicity itself, yet when served it exhibits the epitome of elegance. Simply make incisions, deep-fry, and press down gently. The trick is to space your cuts evenly so that when the eggplant is pushed down to form the flower, the "petals" spread out cleanly for a spectacular finish. The eggplant is topped with a boiled egg yoke seasoned with miso and a sprig of tempuraed greens, but add any food that brings out the eggplant's rich purple hue.

1 | Cut the top from an eggplant to form a flat base. Make evenly spaced incisions from top to bottom, stopping short at each end.

2 | Deep-fry in hot oil, putting the top end (cut end) in first and holding the eggplant in place for a few seconds.

3 | Cook the other side, top up, until soft in the center. Remove from the oil, drain, then set the eggplant on a clean surface and press down gently to form a round shape.

Eggplant Chrysanthemum in a Japanese Wine Sauce

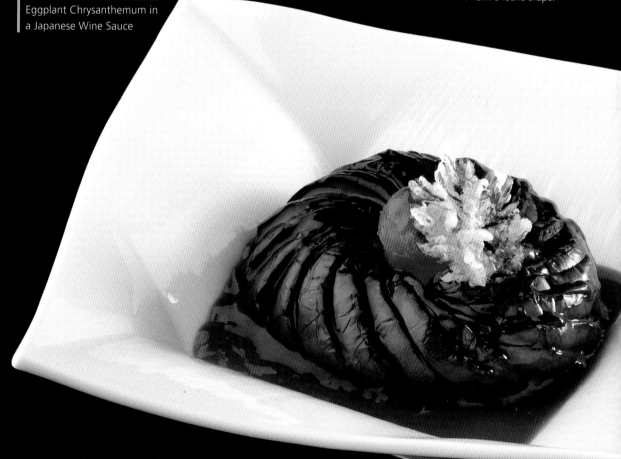

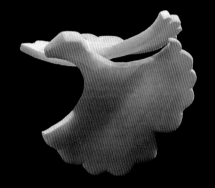

Advanced Cuts

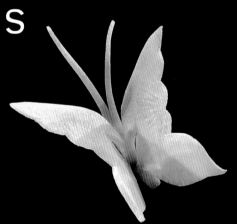

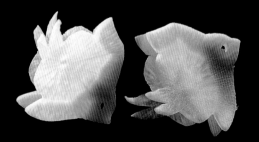

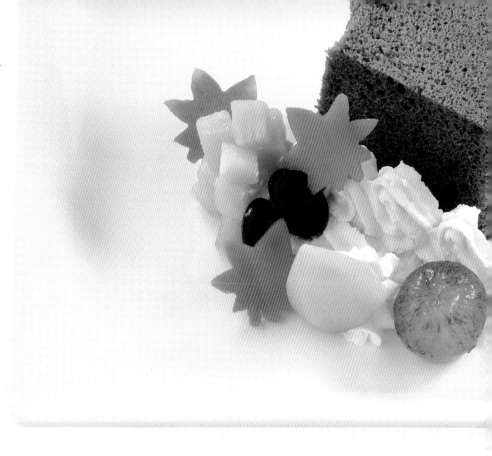

Matcha Chiffon Cake

Maple Leaf

A festive cornucopia of glazed maple leaves, fruit, and assorted delicacies laces the whipped cream accompaniment for this green tea–flavored dessert. As with every other item in this section, this garnish goes well on salads, vegetable dishes, and other hard foods. Consider a similar setup for your favorite cake or pie. The carrot leaves are glazed to give them a subtle sweetness appropriate for dessert (see the Recipe Notes for page 73).

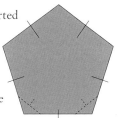

1 | Make the pentagon shape on page 59, then clip off the bottom corners.

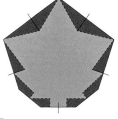

2 | Carve the top of the leaf first. The deepest top cut between points should be about ⅛ inch (4–5 mm).

3 | Continue until top cuts are finished.

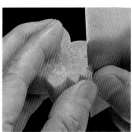

4 | Do bottom cuts following the pattern. Note that incisions will not go as deep.

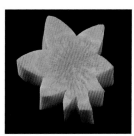

5 | The finished shape.

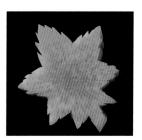

6 | If desired, add more detail to the leaf.

Holly Leaf

This popular French dessert comes to life with this holly-shaped garnish, the powdered sugar completing the festive holiday theme. The Holly Leaf could garnish any fall or winter festivity, from Thanksgiving through the new year. Glaze for desserts.

1 Cut a small, ¼-inch-thick (6-mm) piece from a zucchini. With a food carving tool or a hollow tube, begin making U-shaped cuts.

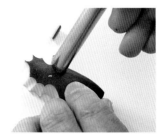

2 Make cuts along the other side.

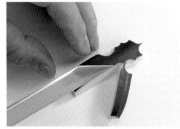

3 Trim to make the stem of the Holly Leaf.

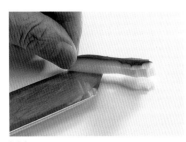

4 Cut in half.

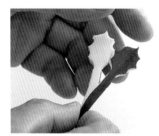

5 Spread to finish.

Mont Blanc

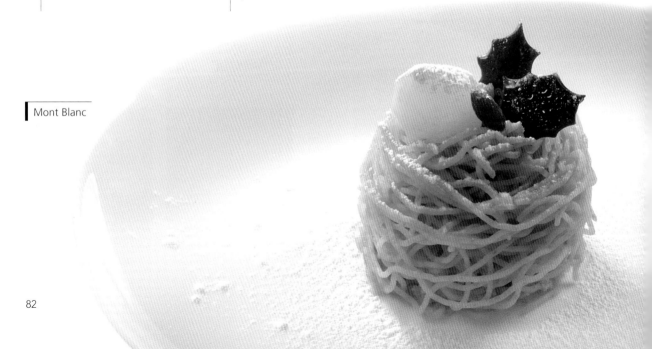

Swallow-in-Flight

Swallows-in-Flight lend a sprightliness to this refreshingly light sweet. Made from zucchini and glazed, the garnish adds just the right touch to the appropriately somber tones of the tableware and jelly itself. Use with meat, fish, and vegetable dishes, decoratively arranging two or three birds alongside the main course.

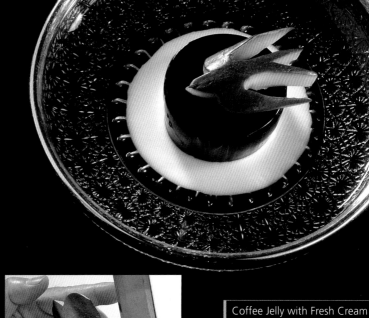

Coffee Jelly with Fresh Cream

1 | Cut a 1½-inch (4-cm) length from a zucchini, then slice in half vertically and trim until ⅓ inch (7–8 mm) thick. Make two V-shaped cuts as shown. The outer cuts should be shallow and curved to form the tops of the wings. To form the head of the bird, make steeper cuts on the center point, shaping the head and beak as shown.

2 | To make the wings and the tail, make an angled cut in the bottom and . . .

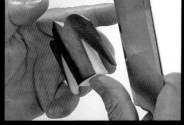

3 | . . . a straight cut for the tail section. Repeat on the other side.

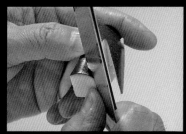

4 | Make a curving V-shaped cut in the center of the tail.

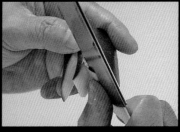

5 | Make curving cuts on the outside of the tail to finish the tail and wings.

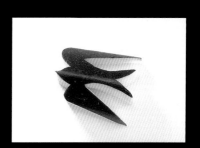

6 | The finished bird. Cook to taste.

83

Butterfly

This charming butterfly garnish enthralls children and adults alike in much the same way as an enchanting animated feature film. Combined with cake, pudding, or jello, or set on a dinner plate of meat and potatoes, this decoration will elicit delight from one and all. For desserts, it is glazed.

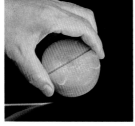

1 | Cut a round slab from a peeled carrot, then halve.

The butterfly shape to be carved

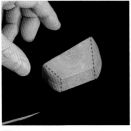

2 | Cut the bottom off at an uneven angle, then cut the sides.

3 | Your carrot should look like this.

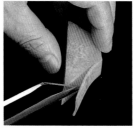

4 | Make an incision to form the antenna.

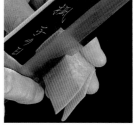

5 | Cut the top of the wings, using the sketch as a guide. Make the center incision first, then . . .

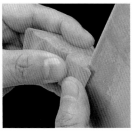

6 | . . . cut to the center point from both sides.

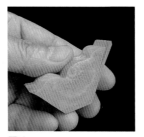

7 | Carve the back side of the wing.

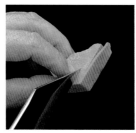

8 | Make an angled incision on the bottom.

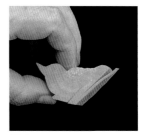

9 | Your butterfly-in-progress should look like this.

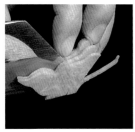

10 | Cut one wing by making an incision close to, but not all the way to, the bottom. Make a second incision to form a second wing. Cut all the way through to separate the butterfly from the pack. Repeat.

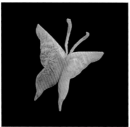

11 | Spread the wings and gently push the front inward slightly until it overlaps. This will keep the wings open.

Japanese Pumpkin Pudding

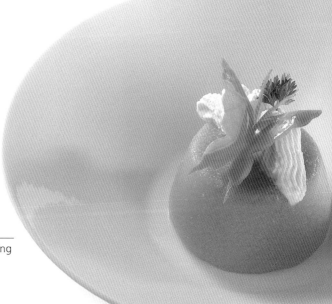

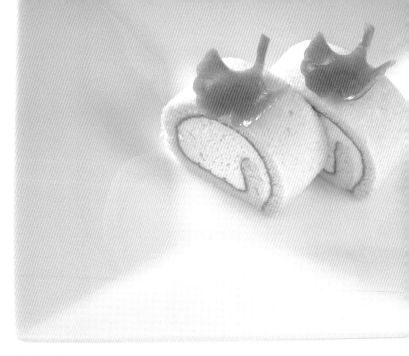

Gingko Leaf

The luscious, fanciful curves of the Gingko Leaf garnish allows for many applications. Here, it appears atop a dessert offering, the only splash of brightness among two shades of white. Perfect for carrot cake (naturally!) and a roster of other sweets. For dessert use, the Gingko Leaf garnish was glazed with sugar and Cointreau (see the Recipe Notes for page 73). To decorate a dish for a formal lunch or dinner, consider sprinkling on a combination of gingko and maple leaves.

1 Cut a 1-inch-thick (2.5-cm) round from a peeled carrot and make two curved cuts with a food carving chisel (or small spoon or knife) to start the curves at the base of the leaf. Make the second one higher than the first.

2 Make a straight cut to the edge of the carrot to form the leaf stem.

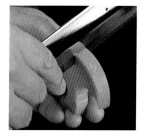

3 Make a shallow cut in the center of the carrot about ¼ inch (4 mm) deep.

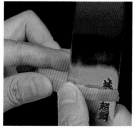

4 Carve the wavy pattern on the top of the leaf, starting from the outside and working toward the center cut made in step 3.

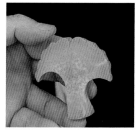

5 At this point the garnish should look like this.

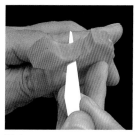

6 Trim the stem to make it thinner.

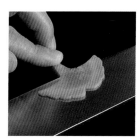

7 Cut off thin leaves until finished, or make two-ply leaves by cutting to the top of the stem, then make a second cut all the way through.

Goldfish

Another showstopper, this Goldfish garnish must be seen to be believed. Suspended in a clear gelatin desert, the fantailed fish seems to come to life. Instructions call for a three-ply fantail, but you can increase that to four or five with a few extra swipes at the tail with a fine-edged knife and a marginally thicker fish body.

Side view of goldfish to be cut from carrot round.

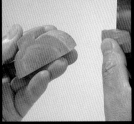

1 | From a large half-round of carrot about ⅓ inch (8 mm) thick, carve out the top fin of the goldfish.

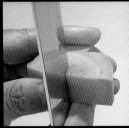

2 | Make an incision just to the left of center about ½ inch (1.3 cm) deep.

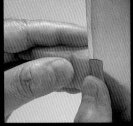

3 | Cut the bottom curve of the head.

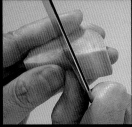

4 | Make a second cut in the bottom to form the first triangle in the rough shape of the first bottom fin.

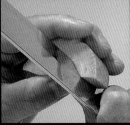

5 | Make a second incision in the bottom slightly shallower than the one made in step 2.

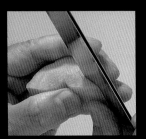

6 | Make a second cut to form a triangle and make the rough shape of the second bottom fin.

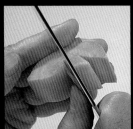

7 | Go back and trim to make the final shape of the two bottom fins.

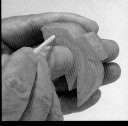

8 | Pass a skewer through the carrot to make the eye.

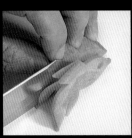

9 | Make the first of four goldfish as follows: with a *thin* knife make two cuts in the tail starting from near the front of the top fin, then make a third cut to finish the goldfish. Make three more fish.

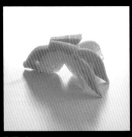

10 | The finished Goldfish.

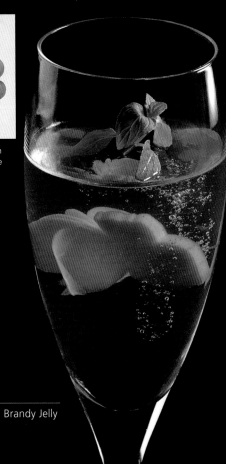

Brandy Jelly

Plover

Here, three Plovers skim over waves of almond-flavored jelly. A bird common around the world, the plover is a great subject for a garnish, and as it is often seen playfully gliding above the waves it has poetic images many people will be familiar with. The eye is tinted with Amaretto. Try making the Plover from carrot or turnips.

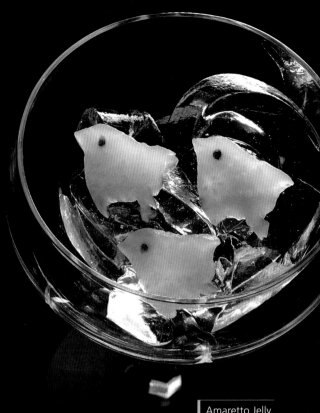

1 | Cut a thick half round from a daikon radish about ¼ to ½ inch (6 to 13 mm) thick, depending on how many birds you want to make.

2 | Cut off the front and back ends of the half-round, following the guidelines in the sketch.

Amaretto Jelly

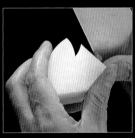

3 | Carve out the triangular notch just below the top wing.

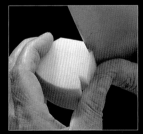

4 | Carve out the triangular notch just above the bottom wing.

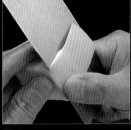

5 | Shape the top of the bird, following the shape shown in the sketch (removing the peel as you go if you haven't already done so). Carve the bottom of the bird.

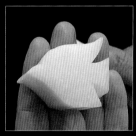

6 | The shape to this point should look something like this.

7 | Carve out the tail in two steps, following the dotted lines in the sketches.

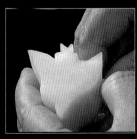

8 | Clean up your cuts to make the final shape of the bird.

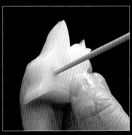

9 | Use a skewer to make the eye.

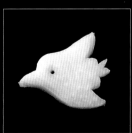

10 | Use the bird as is, or cut thinly across the face of the carving to make multiple birds.

PART

IV

FRUITS

Swan Basket

The elegant yet simple form of a swan floating on the water will delight diners of all ages. Stacked inside is sliced kiwi fruit, but other sliced fruits, alternating or alone, work equally well with this versatile garnish. Or try a handful of whole strawberries and cherries. For a child's party, individual swan cornucopias filled cookies, chocolates, or candies could elevate you to hero of the day. At the very least, you will have a crew of very satisfied partygoers. For color variation, try a pink grapefruit or large orange.

Stacked Kiwi Fruit

1 | Stick 3 skewers into the fruit as shown, forming a triangle around the upper third of the fruit.

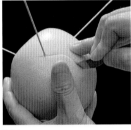

2 | Begin cutting just under a skewer. Where the line passes under the skewer will be the crown of the bird's head.

3 | Remove the skewer and carve out the head, dips, and upper edge of the wings.

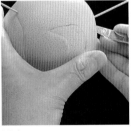

4 | Make a cut on each side to the other two skewers, each of which marks the high point of the wings.

The back of the fruit will be carved in this pattern.

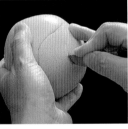

5 | Cut the zigzag pattern for the feathers at the back of one wing, then dip down to make the low U-shaped cut.

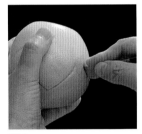

6 | Make the zigzag cuts for the tail feathers.

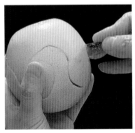

7 | Complete the circle by cutting the zigzag feathers for the second wing.

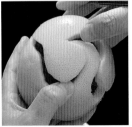

8 | Lift the top half off. Scoop out the fruit to use here or later.

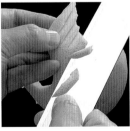

9 | Make notches in the wing that expose the white pulp underneath.

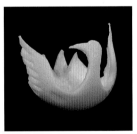

10 | The finished Swan. The shape of your bird may vary depending on the circumference of the fruit.

Swan Curl

This fanciful garnish lends a playful touch to any dinner or pre-dinner snack or dessert. Carved from the peel of a grapefruit, here the body of the swan serves as a platform for the gelatin. Try other "dry" desserts or appetizers. At a party, you might consider mixing up the colors by using pink grapefruits and large oranges to create a more festive atmosphere. Or extend the neck to make a pink flamingo.

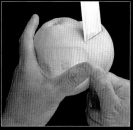

1 | Cut away the center section of peel and pith all the way around the fruit.

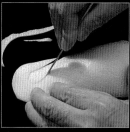

2 | Make a U-shaped cut to form the beak and neck.

3 | Trim the top edge to round out (if necessary), then make a curved cut to form the top of the tail.

4 | Make long narrow triangular cuts to form the tail feathers.

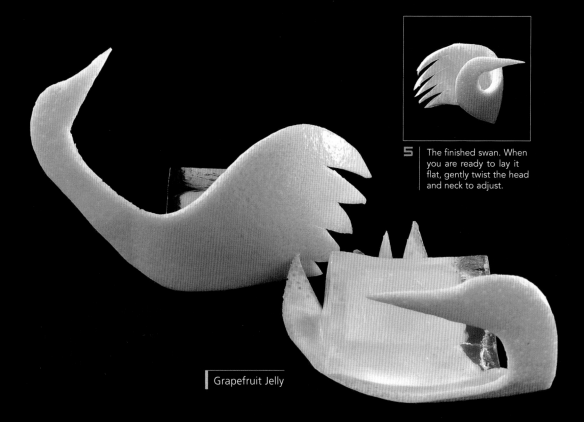

5 | The finished swan. When you are ready to lay it flat, gently twist the head and neck to adjust.

Grapefruit Jelly

Serrated Cup

Pinched for time but need an additional flourish at the dinner table? This serrated fruit is fast and easy to make. Add flavored jelly, as here, or a scoop of ice cream with nuts and whipped cream, or for simple elegance, a meal-ending scoop of sorbet. Fresh papaya with a splash of lemon and strawberries and whipped cream is a crowd-pleaser any day of the week.

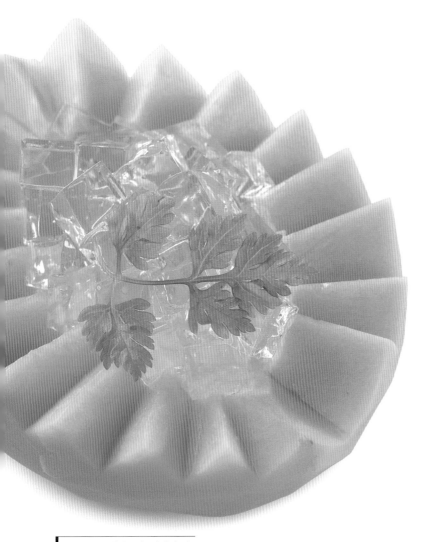

Papaya and Crushed Gelatin

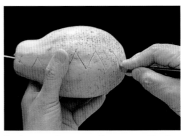

1 | Insert skewers in the center of both ends as visual reminders to stay in the center as you cut. Make a zigzag cut around one side.

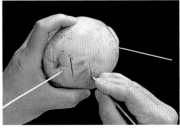

2 | Continue to cut in a zigzag pattern all the way around the fruit.

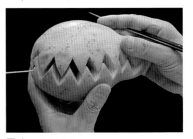

3 | Pull the halves apart.

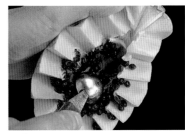

4 | Scrape out the seeds and rinse the fruit.

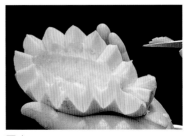

5 | The finished garnish.

Fruit Basket

Edible garnishes is one of the themes of this book and it is echoed here with this carved papaya basket. Select berries and other fruit not only for taste but for color. Make use of the freshest seasonal fruit. A dab of whipped cream is optional. Choose tall, wide-bodied papaya. Serve with a small dessert fork.

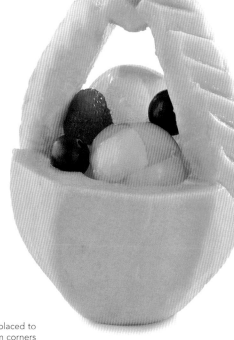

Papaya Dessert Basket with Berries

1 | Trim the top of the fruit.

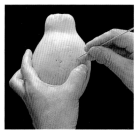

2 | Find the midway point between the top and bottom and stick in a skewer. This will mark a bottom corner of the handle.

Skewers should be placed to mark out the bottom corners of the handle, first two on the left side, then on the right.

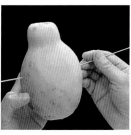

3 | On the other side of the fruit, insert another skewer where the bottom corner of the same side of the handle will be.

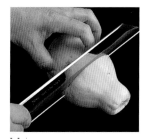

4 | Make a cut at the center of the fruit to the skewers.

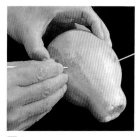

5 | Turn the fruit over and reposition the skewers to mark the other two bottom corners of the handle, then repeat step 4.

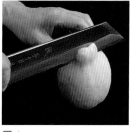

6 | Make a vertical cut to carve out one side of the handle and . . .

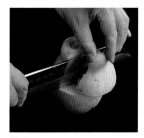

7 | . . . remove the wedge. If you want to serve the fruit peeled, as shown in the finished Fruit Basket, then peel at this stage.

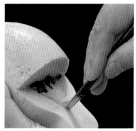

8 | Before cutting the other side, carve the underside of the handle for a nicer shape if desired.

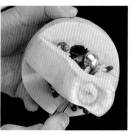

9 | Repeat steps 6 and 7 for the other side, then remove all the seeds. If the fruit has a thick wall, you may want to notch the handle. If you do so, support the handle as you cut and proceed carefully so as not to break the handle or cut yourself.

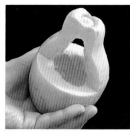

10 | The finished garnish.

93

Carved Bird Basket

If you're looking to flex your creative muscles, this basket with its layered wings is the way to go. A single bird can serve double duty as a centerpiece in an intimate tête-à-tête for two, while a flock will leave diners wide-eyed with amazement. A peeled melon and large apple are shown here. Fill with fruit balls or stack bite-size pieces attractively. Consider green apples.

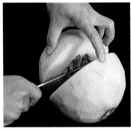

1 Peel the fruit, cut in half, and remove the seeds. Keep in mind the finished bird will have 4 pieces: the body, the head, and the wings.

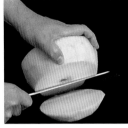

2 Cut a generous portion off the bottom of one half. The head will be carved from the bottom piece, the wings from the top.

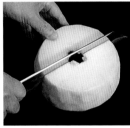

3 Cut the top portion in two and then . . .

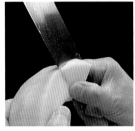

4 . . . trim the corners of each piece to make a point at each end.

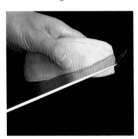

5 Cut the layers of the wing by first cutting a large V-shaped wedge and . . .

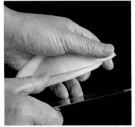

6 . . . sliding it off. Set aside the large notched piece.

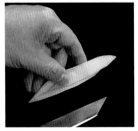

7 Repeat steps 5 and 6 to cut a second wedge, followed by a third, and so on. Cut as many wedges as you can. Reassemble the pieces, then repeat the process to make a second wing.

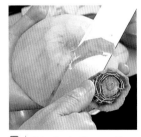

8 Take the bottom portion cut in step 2 and trim nicely.

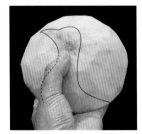

9 The head and shoulders of the bird will be carved from this piece.

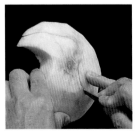

10 Carve the head and shoulders.

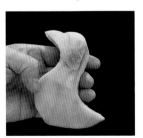

11 The finished head-and-shoulder combination.

12 Trim to thin the head.

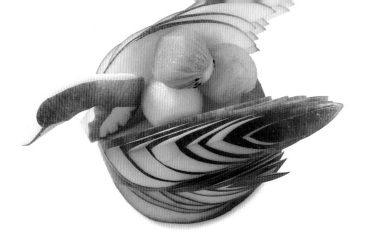

13 From the remaining half of the fruit, carve out a wedge to make a second pair of wings.

14 Cut out the wedge at the angle shown, nearer and pointing to the front of the bird.

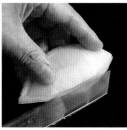

15 Cut a smaller wedge and . . .

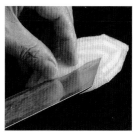

16 . . . continue to cut ever smaller wedges. Repeat on the other side.

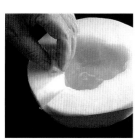

17 Cut a V-shaped notch for the head and shoulders.

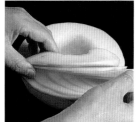

18 Insert the notched wings back into the body and arrange, then add the second pair of wings on top.

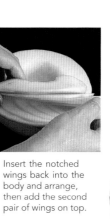

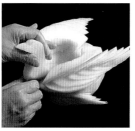

19 Insert the head-and-shoulder portion into V-shaped notch.

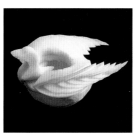

20 The finished Bird Basket.

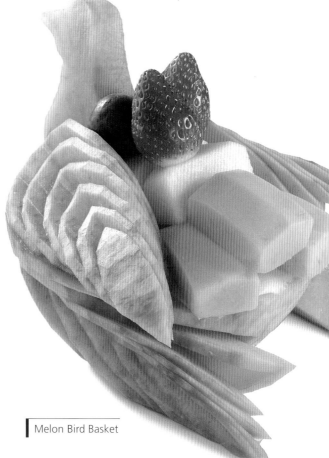

Melon Bird Basket

Diamond-Studded Jewel Box

Stuffed with fresh slices of apple, fruit balls, berries, sweat adzuki beans, a small scoop of ice cream, and more, this Jewel Box of savory tidbits will delight one and all. To heighten the dining experience, vary the items you stuff into the apple and bury some of the tastier morsels so that they are only revealed as the upper foods are eaten.

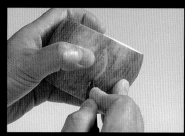

1 | Cut the top of an apple off (see step 6 for proportions) and trim a little off the bottom of the apple for stability.

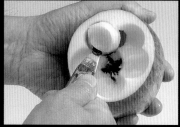

2 | With a melon scoop, scoop out the inside, but leave some fruit inside to make the cutting in step 3 easier.

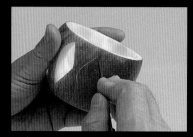

3 | Cut diamonds in the side.

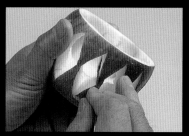

4 | Go back and clean up the diamonds, if necessary.

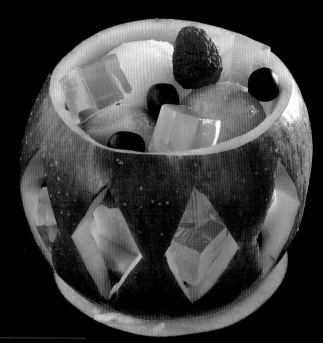

Sliced Apple Fiesta

5 | Finish removing apple from the inside and trim the rim.

6 | Serve the apple with the apple balls as is, drizzled with honey, or add other foods if desired.

RECIPE NOTES & TOOLS

NOTE: The recipes for **Japanese Wine Sauce** can be found in the entry for page 14, for **Glacé** on page 73.

PART I SIMPLE ACCENTS

TWISTS & CURLS

■ Sashimi Platter PAGE 13

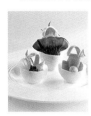

For a sashimi combination, set out soy sauce and *wasabi* horseradish, or mix the two up ahead of time and sprinkle over the hors d'oeuvres just before serving. Choose your sashimi by season and only select the freshest seafood. When in doubt, avoid it. Consider mixing the fish in season with sea urchin (*uni*) or salmon roe (*ikura*). For a cocktail party or a formal dinner try bite-size cubes of duck, smoked salmon, and tender steak, all individually seasoned. Sautéed duck with onion and parsley in a carrot dressing is a crowd-pleaser.

■ Abalone Steak with Foie Gras page 14

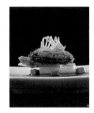

The abalone steak was grilled lightly in oil and seasoned with salt and pepper to taste. It rests on a bed of asparagus and potato and is served in a **Japanese Wine Sauce** made with pan juices and 1 part white wine, 1 part saké, and 1 part soy sauce. Mix the wine and saké in a fresh saucepan, burn off the alcohol over a low heat, then add the soy sauce, juices, salt, and pepper (or sugar) to taste. See the Recipe Notes for page 73 for a **Glacé recipe**.

■ Asparagus and Potato Appetizer page 15

The appetizer in this boat-shaped serving vessel relies on two crisp, parboiled vegetables. While the garnish supplies the visual spice, the dab of mustard and jelly from the aloe vera plant serve as condiments. Varia-

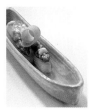

tions on this appetizer would include substituting lightly boiled turnip or daikon for the potato, each lightly seasoned to taste with salt, pepper, and soy sauce. Season the carrot as desired, or glaze.

DECORATIVE KNOTS

■ Duck and Red Snapper on Daikon Steak page 17

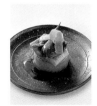

Roasted duck over lightly grilled snapper and succulent boiled daikon is a mouthwatering treat and a hard combination to beat. The whole is seasoned with a Japanese Wine Sauce made from the pan juices (see Recipe Notes for page 14). Stack the three foods, garnish, and spoon on the sauce. Vary the fish or the poultry to fit the season or your own cooking repertoire. For more on daikon, see the Recipe Notes for page 75.

■ Beet Soup page 18

The boiled daikon was chosen for its mild flavor, a nice counterpoint to the tart, distinctive flavor of the beet. The soup here is served hot, but this decorative technique can be used with hot or cold soup alike. Simply vary the colors of the vegetables and garnish to create an appealing effect.

■ Potage with Minced Shrimp and Egg page 19

A good potage is filling, subtle, and easy to make. Next to the sprig of submerged broccoli is an island of minced shrimp briskly cooked in a fry pan with egg

yolk, mayonnaise, and salt and pepper to taste. Simple, heartwarming, and pleasing on a deeper level, the way hearty food should be.

REFRESHING ACCENTS

■ Spiny Lobster

pages

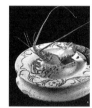

Boil a lobster whole in a large pot and serve seasoned with a dab of mayonnaise or melted butter. Don't be afraid to turn the lobster itself into a decorative part of the dish, as is done here by opening up the head and tail.

FOOD CUPS

■ Roast Duck on a Half Lime

page

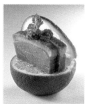

A zesty lime works nicely with roasted duck. While a lemon might be too astringent, an orange echoes the classic orange sauce combination and, of course, leads to a brighter display. The secret here is to allow the duck—or whatever food you choose to present—to draw up the citrus juices through capillary action.

■ Calamari Topped with Salmon Roe page

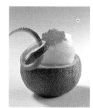

With the popularity of sushi, salmon caviar has come to the fore in American cuisine. Here, its distinctive tartness, along with its soft liquid center, provides flavorful and textural counterpoints to the more mellow calamari—an appealing combination an inventive cook can take in many directions. The sashimi-fresh calamari is cooked lightly, the soft center left near its raw state and then seasoned with salt and pepper.

■ Marinated Salmon with Olive and Onion

page

There are dozens of recipes for Marinated Salmon, each as good as the next. Marinate the fish follow-

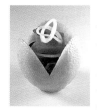

ing your favorite recipe and add the expected slices of onion, then olives, which add a darker hue and a richer flavor to the mix. The slices of olive also echo the roundness of the onion and the lemon, bringing the dish together visually.

■ Risotto in Japanese Pumpkin

page

The **Japanese pumpkin** (*kabocha*) is another long-neglected Japanese food that is slowly finding its way in the world. It is a tasty and versatile vegetable good for soups and vegetable dishes, or as a stand-alone side dish. Wedges are baked or simmered in a stock such as Japanese *dashi* for about 25 minutes until soft and then seasoned in a saucepan with a sauce of ¼ cup (60 ml) soy sauce, 1½ tbsp of sugar, and 2 tbsp of *mirin* (Japanese cooking saké, or increase the sugar) for 20 ounces (600 g) of pumpkin. The *kabocha*'s natural sweetness is highly valued among Japanese cooks.

CUCUMBER CARVING

■ Salmon, Cheese, and Cucumber

page

The **Japanese cucumber** has begun to appear on American supermarket shelves, and seeds are now an option for vegetable gardens in some areas. Crunchy, light, and edible raw, Japanese cucumbers—along with carrots, red radishes, and daikon radishes—are perfect material for decorative food art. They do not require marinating or salting before use.

■ Toast with Jam

page

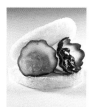

This creative presentation for toast raises the normally pedestrian-looking food a level and is sure to draw the diner's eye. Since the finely sliced cucumber is light and crisp, the toast can be eaten as is, or the Mini Cups can be pulled out and the condiment of choice can be spread over the toast.

■ Tuna Salad, Cucumber, and Egg page -❷

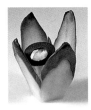

Tuna Salad is a welcome favorite at many tables. Whether made from fresh fish or canned, how you spice it up determines the appeal of the final dish. Consider fluffing it up with boiled or lightly scrambled egg, diced and seasoned with salt and pepper to taste. Depending on your likes or dislikes, add diced onion and olive. Seasoning with minced garlic, olive oil, and wine vinegar can give new life to this standard dish.

■ Cucumber and Tomato with Orange Dressing page 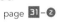-❶

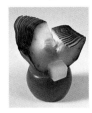

This cucumber-and-tomato appetizer is seasoned with a cube of orange dressing that has been set in unflavored gelatin. This culinary trick allows the cube to fulfill three functions: it adds color, provides flavor, and secures the cucumber. Try this hors d'oeuvre with other "cubed" dressings. Slice off the tops of the cherry tomatoes to create a base on which the crane can perch.

■ Crab and Cucumber Canapé Topped with Salmon Roe page 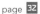-❷

The crisp, light taste and texture of the Japanese cucumber make the perfect counterpoint for any number of tender morsels of meat, poultry, or seafood. For simplicity of preparation, try slices of cheese with a dollop of dressing, or toss on some baby shrimp or diced barbecued chicken for a two-minute fix. For something more elegant, consider thin slices of lightly grilled marinated lamb or thinly sliced scallop sashimi seasoned in a light *wasabi* sauce.

■ Dinner Crepes with Japanese Eel page

For a simple yet exotic dinner, stuff crepes with grilled **Japanese eel** (*unagi*), a delicacy that is gaining popularity outside Japan. The tender, freshwater fish can be found in specialty stores in vacuum packs, filleted and pre-cooked with the appropriate seasonings. Bring a rare but exceedingly tasty treat to your table. One additional tip: choose

eel from Japan over those from China. The tenderness and taste of the original surpasses the contender. Beware imposters labeled Made in Japan.

■ Grilled Sea Bream page

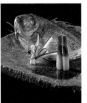

In Japan, **fish** makes up a vital part of the diet. Our finned friends provide us with succulent dinner table dishes in many forms—grilled, steamed, sautéed, doused in a flavorful sauce, and of course raw, in the form of sashimi. The array of fish available in Japan outshines that of many other countries, but even so finding a purveyor of *fresh* seafood in the neighborhood will be a boon for the adventurous cook. So consider seeking one out if you haven't already done so, and use their offerings liberally to enliven your table and expand your cooking repertoire.

■ Cucumber Corkscrews with Crab and Cheese page

With a source of Japanese cucumbers close at hand, this idea will work with salami, ham, grilled chicken slices, or parboiled vegetable sticks. Choose an appropriate dipping sauce. Simple and fun to serve and eat.

■ Sardines in Two Sauces page

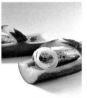

Not only do these cucumber baskets provide a receptacle in which to lay your dressing or sauce, they lend a neutral, crunchy texture over which you can lay your own favorite appetizers or finger foods, whether they be slivers of spicy chicken, marinated skirt steak, or seasoned vegetables. Be inventive.

PART II KATSURA-MUKI

■ Hors D'oeuvre Platter

pages 44–45

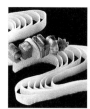

While this table garnish is obviously amenable to countless variations of appetizers, the hors d'oeuvres here, from left to right, are 1. Asparagus and Prosciutto, 2. Cheese and Papaya Wrapped in Salmon, 3. Parboiled Lotus in Sweet Vinegar, 4. Sautéed Scallops with Egg, 5. Shrimp and Caviar, 6. Melon (*uri*).

■ Vegetable and Cheese Sticks

page 46

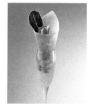

Celery and carrot sticks have been mixed with strips of cheese in this offering, the whole chilled on ice placed in the bottom of the flute glass. A perfect spring or summer treat. Consider salami or ham sticks with cheese. Or you might block off the bottom half of the lily cone, or set it in a slightly wider vessel and add a scoop of salad, either potato, tuna, or crab.

■ Sashimi Select

page 47

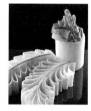

Sashimi gathered fresh from the sea and brought still fresh to the dinner table is not something that should be taken for granted, even among the most experienced eaters. This copious Wisteria garnish does justice to the food and vice versa. Choose other, equally deserving offerings from your cooking repertoire to serve in this fashion and your diners—whether guests or family—are sure to be impressed.

■ Papaya and Salmon Roll, Asparagus and Prosciutto Roll, Tuna Sashimi and Japanese Long Onions

pages 48–49

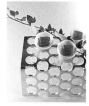

So many of the decorative garnishes in these pages lend themselves to simple appetizers or finger food that can be whipped up in seconds but are—the time factor not withstanding—a delight to the palate. Sashimi, always a favorite in Japan, lends itself to numerous combinations, whether paired with onion, avocado, or a *wasabi* sauce. Asparagus, another favorite for its tender yet crunchy texture, can be covered in any number of wrappings, whether meat or fish. Use your imagination and be creative. Think outside the box a la Papaya and Salmon Roll, a combination distilled from more complex recipes.

■ Sushi Balls with Sprig of Ginger

page 50–❶

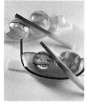

Follow any sushi recipe and season rice for sushi, then roll rice into small, bite-size balls. Cut fish so it drapes nicely over the rice, place on top and shape gently to finish. Here shrimp and *sayori* (needlefish or halfbeak) are used, but any flexible sushi topping will work. Or try other round food— shrimp balls, meatballs, or any appetizer that lends itself easily to a circular shape.

■ Prime Rib Cubes over Sautéed Zucchini

page 50–❷

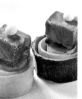

The prime rib is topped with a ball of horseradish and should be served with steak sauce or a dressing of your choice. Season with salt and pepper to taste. In the meat department, cubes of chateaubriand or another piece of tenderloin will work equally well. For seafood, consider sautéed scallops or fried oysters. When dealing with seafood, for best results choose fresh specimens in season.

■ Salmon Mousse and Sole Wrapped in Zucchini

page 51

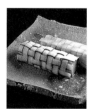

Sole is used here, but any tender whitefish, lightly grilled or steamed, can be served. Lightly sautéed, the tender flesh of the sole melds perfectly with parboiled zucchini. Both are soft and succulent. The Salmon Mousse, delicate and airy, also complements its zucchini covering to perfection. Give new life to some of your own standard dishes by wrapping them in Zucchini Fish Nets, then stand aside and watch the delight of family and friends when they see your makeover.

PART III CUTOUTS

SQUARE CUTS

■ Steamed Pork with Mustard Sauce page 55

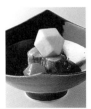

The steamed pork dish here is served in a mustard sauce made with pan juices. Pick a light, spicy French mustard, perhaps a Dijon. The other trick with this dish is not to just boil the vegetables in plain water but to cook them in a complementary broth and surprise the diner, whose eyes alight on the pork but whose tongue signals an unexpected taste.

■ Smoked Salmon Pâté with Vegetables page 56

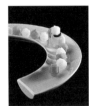

Consider this or a similar presentation for pâté or any other dish in your repertoire that deserves the attention. Smoked Salmon Pâté is a rich, healthier alternative to the classic pâté dish and is easily made.

■ Shrimp Tempura page 57

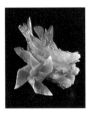

Everyone loves a **good tempura**, which should be light on the tongue and nearly oil-free. The last is accomplished by using a light, high-quality vegetable oil, the first by mixing the batter using 1 part ice water to 1 part sifted flour *roughly and just before you are ready to deep-fry*. For a richer effect, decrease the water by 20 percent and add 1 egg yolk. Preheat the oil to about 340°F (170°C). Test oil, then mix the batter but leave it unevenly mixed. Beat egg yolk, blend with ice water in a few strokes, then add flour and mix in a *few simple strokes*. If you are cooking a large batch of tempura, make the batter in batches. Use the freshest shrimp, vegetables, and seafood. Tamp food dry, coat lightly with flour, then dip in batter.

PENTAGONAL CUTS

■ Daikon Plum Blossoms Seasoned in a Chicken Broth page 60

As mentioned in the Recipe Notes for the Parboiled Daikon with Tomato Sauce on page 75, daikon radish

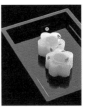

is a good vegetable to add to your cooking repertoire. Wrapped and refrigerated, it keeps well. It works well in salad or cooked, as it is here, seasoned in a chicken broth. The egg yolk is spiced with Japanese *sansho* pepper, a mild flavoring. Consider salt, pepper, and chopped parsely, or sautéed minced onion.

■ Brandied Carrot Blossoms page 61

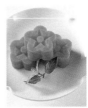

Brandied carrots have always been a crowd-pleaser. Parboil ½ pound (225 g) of carrot blossoms until they are tender but still crisp. Drain and set aside. Preheat an oven to 325°F (160°C). Combine 1 ounce (30 ml) of brandy, ¼ cup (60 ml) of melted butter, ½ tbsp of brown sugar, and salt to taste. Place the carrots in a casserole dish and coat with the brandy mixture. Bake for 20 to 30 minutes.

■ Carrot and Daikon Salad with Prosciutto page 62

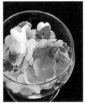

Daikon and carrot are an excellent combination for a salad, and here a small portion makes a superb meal opener. Both vegetables are crisp and fresh, and thinly sliced lie light on the tongue. Consider replacing the prosciutto with baby shrimp or diced sautéed scallops, or for a purely vegetarian offering, use avocado.

■ Sweet Potato with Blueberry Mousse page 63

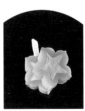

Just like a good gelatin (jelly) recipe, a **mousse recipe** can work wonders in your kitchen. Both are versatile foods that you can use to easily expand your cooking repertoire. Both are also easy to make. If you haven't done so already, you should seriously consider adding a basic mousse recipe to your culinary skills. Find a basic recipe that works well for you, keep the ingredients handy, then add flavoring to match your needs. A tart Blueberry Mousse works well here, a Salmon Mousse on page 51. There are dozens of other dinner and dessert flavorings you can add to suit any occasion. Experiment. Dive in and be creative!

■ Potato and Shrimp page -

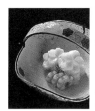

There are many ways to **cook shrimp**. Here, it is boiled in water with a splash of saké (1 part to 10 parts water) and a pinch of sugar. If you are fortunate to find fresh shrimp, choose the freshest catch for the best results. Shell and remove the dark vein, and cook just enough to bring out its natural tenderness. Avoid overcooking.

■ Shrimp and Bell Peppers page

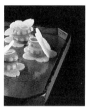

Choose fresh shrimp and bake (as is done here), boil, or sauté lightly to bring out its natural succulence, then layer in other flavors to complement the taste of the shrimp. Two mellow foods are inserted here, with a tart, juicy finish provided by the green kiwi. Try your own favorite inserts. Consider, for example, three shades of bell pepper—yellow, red, or green—to echo this visual arrangement, or slices of other vegetables, including avocado.

■ Japanese Pumpkin Pudding page 66

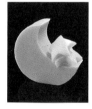

The recipe for pumpkin pudding appears in the Recipe Notes for page 84. To make the moon, bake the pudding slightly longer to make it firmer, and in a large, shallow baking dish instead of individual cups. Punch out circles then carve the moon shape. An another method would be to fill well-oiled individual cups to about 1 inch (2.5 cm), bake, gently knock out the finished pudding on a cutting board, then shape. Glaze the zucchini.

■ Steak and Carrot page 67

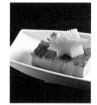

Most likely you noticed the "unusual" presentation of the steak here. Not only is it trimmed to a neat rectangle, but it is **cut into bite-size pieces**. This is an old Japanese tradition born out of necessity because of the use of chopsticks. Most Japanese food, as a visit to a Japanese restaurant will confirm, is cut into small pieces that may be brought directly to the mouth without the diner having to cut up the food first. Consider this **Japanese-style presentation** for a particularly tender or high-grade steak. Use a large, well-sharpened knife.

FREE CUTS

■ Lightly Vinegared Carrot page 69

The carrots are parboiled to make them tender but still crisp, then seasoned with a light vinegar for a zestier flavor.

■ Toast and Vegetable Hors D'oeuvre page 70

The petals are shaped before the bread is toasted, then the carrot and daikon are laid on top, facing inward. The original inspiration for this dish was Garlic Toast, an equally tasty idea for this pattern.

■ Zesty Ginger Ale Jelly page 71

Flavored gelatins should be a part of your cooking repertoire, as they are easily made, high in protein, and adaptable to many flavors that will complement your meal of the day. A simple rule of thumb of 20 to 1 should guide your efforts. That is, 20 parts water, sugar to taste, and flavoring agent (in this case 3 oz/90 cc of ginger juice) to 1 part gelatin. Bring water and other ingredients to a boil, then add gelatin powder to the mix, following the directions on the package. The one caveat is that certain ingredients—including raw ginger juice, kiwi, papaya, and pineapple—need to be heated in order to disarm the natural enzyme that prevents the gelatin from hardening. As with many of the garnishes here, particularly those made of carrot, the ginger garnish is lightly glazed, or glacé.

■ Smoked Fish and Potato page 72

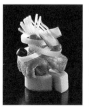

Smoked foods used to fall into the domain of the professional, so people were forced to buy smoked meats and fish. Now a wide variety of smoking options are available to the home cook. While smoking beef and pork have been thoroughly covered on cooking shows and in print, fish remains the neglected cousin, yet it can be the most rewarding—

and the healthiest. The fish here is slowly sautéed with a splash of soy sauce, saké, and *mirin* cooking saké and then smoked. Season fish in this manner or follow your own preferences and then smoke. Smoked fish offers rich, clean tastes, without any fishiness or the fatty taste of meat.

■ Hamburger Steak with Carrot Chrysanthemum page 73

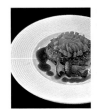

Glacé recipes for glazing are plentiful. The sweetening agent could be honey, sugar, molasses, or brown sugar and the flavoring can range far and wide. If you plan to use garnishes regularly, it would be a good idea to keep a glacé stock ready-made in your refrigerator. The recipe here calls for 1 tsp Cointreau (substitute brandy), lemon to taste, 10 oz (300 g) sugar combined with 2 quarts (1.8 liters) of water. However you decide to cook the Chrysanthemum garnish, do not overcook it. Parboil or steam over a low heat until just tender, drain, and simmer in glacé stock. Or for up to 1 pound (450 g) of carrot, steam or parboil carrot, drain, then in a medium fry pan melt 3 tbsp butter, stir in 3 tbsp honey, 2 tbsp Cointreau or brandy, and a splash of lemon. Add carrots and stir gently, simmering for a minute or two until carrots are glazed.

■ Parboiled Daikon with Tomato Sauce page 75

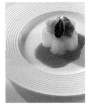

The **Japanese daikon radish** (aka Chinese radish or giant white radish) is a versatile and nutritious food. It is a mild-tasting and crisp vegetable that combines well with other flavors. When boiled, it becomes succulent and absorbent to a degree. Here it is served in a seasoned tomato sauce. Shredded or julienned daikon is a refreshing addition to any salad, or will stand on its own. Chill and then toss with oil and vinegar or a dressing of your choice.

EGGPLANT FANCY

■ Eggplant and Hollandaise Sauce page 77

Miniature eggplants were used for the lilies here, but the ends of larger, slim eggplants will work just as well. Whittle the base of the flower down to size, if necessary. Deep-fry until soft at the center, but do not

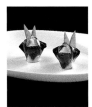

overcook. Check regularly with a skewer. Use a light vegetable oil and drain well.

■ Stuffed Eggplant page 78

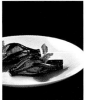

After the Fish Trap is made, the eggplant is deep-fried then the chicken balls are set ever so gently inside, and the Trap is closed up again. Drain the eggplant well before stuffing. Depending on your choice of stuffing, you may want to bake the eggplant and stuffing together, or prepare the stuffing ahead of time and then bake.

■ Eggplant Chrysanthemum in a Japanese Wine Sauce page 79

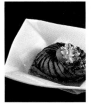

A round eggplant yielded the shape here, but the bulbous end of an oblong specimen will also produce good results. Trim one end flat, make incisions, and deep-fry at about 370°F (190°C). When deep-frying, cook until the center is soft. Test with a skewer. Drain well. For more information on the Japanese Wine Sauce, see the Recipe Notes for page 14.

ADVANCED CUTS

■ Matcha Chiffon Cake page 81

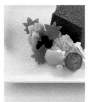

The Japanese powered green tea known as **matcha** has become popular not only as a beverage but as a flavoring agent for main dishes, salads, and desserts. Ground to a fine power, *matcha* tea lends itself easily to a wide range of recipes, including ice cream, scones, yogurt, sauces, syrups, tiramisu, dressings, and gratin. To season a chiffon cake, add 4 tsp *matcha* for every ½ cup (120 ml) of flour.

■ Mont Blanc page 82

The Japanese have taken to this French dessert in a serious way, and it is easily found. If you are fortunate

enough to have this chestnut-flavored dessert offered at a nearby bakery, or you make it yourself, consider decorating it with the holly leaf garnish here, glazed of course, or perhaps with one of the other smaller natural garnishes, such as the Maple Leaf or a small Cherry Blossom.

■ Coffee Jelly with Fresh Cream page 83

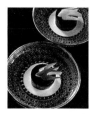

Coffee Jelly is a popular "adult dessert" in Japan. It has a slightly astringent taste and a pleasing coolness appropriate to hot days. There are dozens of recipes around, and they vary in the amount of coffee and sugar, which you should adjust to suit your palate. A basic recipe calls for 2 cups (480 ml) coffee, 1 tbsp gelatin powder, 2 tbsp sugar, a dash of vanilla (optional), and fresh or whipped cream. Strain the coffee to remove any grounds, then add to a pan with the sugar and gelatin over a low heat, stirring until the sugar dissolves. Add vanilla to taste. Let cool then refrigerate. Serve in a pool of fresh cream or top with whipped cream. Makes 4 servings.

■ Japanese Pumpkin Pudding page 84

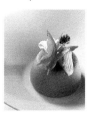

The **Japanese pumpkin** (*kabocha*) has an addicting, naturally sweet flavor that really comes to the fore in puddings. If your local grocer or specialty shop has *kabocha*, the pudding is simple to make—and rewarding. For **Japanese Pumpkin Pudding** you'll need 12 oz (350 g) Japanese pumpkin, 2 eggs + 2 egg yolks, 3½ oz (100 g) sugar, ¾ cup (180 ml) whipping cream, and ⅔ cup (160 ml) milk. Peel the pumpkin, cut into small pieces (discard the seeds), and boil or steam until soft. Combine the eggs and sugar, then add the milk and whipping cream. Preheat an oven to 320°F (160°C). Mix pumpkin and egg mixture in a blender at a *low speed* until well mixed. Pour mixture into oven-proof aluminum cups (for individual servings), set cups in a shallow pan of water, and bake/steam for 50 minutes. The pudding is done when it is solid but still soft throughout.

PART IV FRUIT

■ Stacked Kiwi Fruit page 90

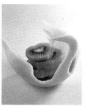

Kiwi fruit is often shunned for its tartness or because some cooks find removing its outer skin too much work. But the harried cook can simply cut the fruit in half and allow the diner to use the skin as a natural cup from which he or she can scoop out the fruit. It is important to allow the kiwi to fully ripen, usually for 3 to 5 days. If you allow its taste to mature (it should be slightly soft to the touch and plump), you'll find kiwi a welcome addition to your table. To hasten the ripening process, put the fruit in a plastic bag with apples, bananas, or pears.

■ Grapefruit Jelly page 91

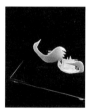

A gelatin dessert with *fresh* fruit instead of canned is a refreshing switch. The reason canned fruit has become a popular addition to for gelatin desserts is that the fruit is precooked and so all the enzymes that would stop the gelatin from solidifying are removed. Fresh grapefruit does not have this problem. Besides the display value of the fresh grapefruit, this gelatin liberates the popular citrus from its perennial role as a breakfast offering. For a basic flavored gelatin recipe, see the Recipe Notes for page 71.

■ Papaya and Crushed Gelatin page 92

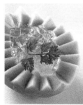

Like the kiwi fruit showcased on the previous page, the **papaya** is a fruit that deserves to have a more prominent role in the Western kitchen. Here, it is carved and paired with gelatin. In the Morning Glory spread (page 48), it is cloaked in a soft layer of smoked salmon. When selecting papaya, pay attention to the skin. Those with reddish-orange skin and slightly soft to the touch will ripen within a day or so and are good for using quickly. Otherwise, choose those with more yellow skin but make sure to avoid fruit with bruising and more than a few black spots. Also avoid specimens that are completely green or overly hard or soft.

■ Papaya Dessert Basket with Berries page 93

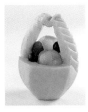

This fruit basket contains a surprise. To a basket of berries, fruit salad balls in aspic were added. Fill this basket with berries and other fruits in season, making sure each item in your selection is ripe and ready to melt on the palate.

■ Melon Bird Basket pages 94–95

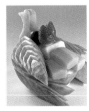

For best results, carve the bird, cut and prepare the fruit inserts, then chill separately and assemble just before serving. To keep apples from turning brown, carefully coat with a weak saltwater solution (1 tsp to 1 quart/1 liter of water). If you think a slight salty taste will be bothersome, brush on fresh juice from a lemon, lime, orange, or pineapple.

■ Sliced Apple Fiesta page 96

Select large apples and consider the color of the specimen. Do you want a darker-skinned red apple, or a lighter-skinned one? Or perhaps a green apple? If desired, dribble honey over the apple slices. Refer to the Recipe Note for the Melon Bird Basket in the previous entry for tips on keeping the apple from turning brown. Serve chilled, with small dessert forks.

T O O L S

KNIVES

The knife is the most-often used tool in this book. Maintain a razor-sharp edge on your kitchen knives and keep a sharpening stone nearby. A fine edge will facilitate clean, accurate cuts.

While any good knife will work, in my professional capacity I use a one-sided blade because I believe it yields cleaner cuts and produces a nicer looking garnish. Since Japanese knives are gaining popularity, I thought I'd introduce some of them here. The first two work especially well for carving garnishes, the next two for *katsura-muki* daikon sheets, and the last for sashimi. Listed by name from left to right, they are *kurimuki-bocho* ("chestnut-peeling" knife), *usuba-bocho* (thin-blade knife), *mukimono-bocho* (garnish knife, small and large), and *yanagiba-bocho* ("willow-leaf–shaped" knife).

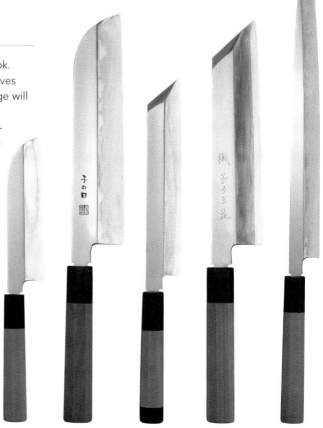

FOOD CHISELS

While you can use a number of everyday utensils to accomplish many of the same tasks, having a set of food chisels in the kitchen will serve you well. Once you familiarize yourself with them, you are bound to find new and inventive ways to incorporate them into your repertoire of techniques. There are two types, curved and V-shaped. The curved edge is used for cutting holes or punching out half-moons, the V-shaped for more detailed work and a pointed cut. As the edges are extremely sharp, use them with care. Place a thick kitchen towel over your cutting board to protect it and the chisel edge.

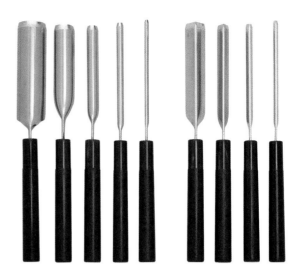

SCALPELS

For detail work, it helps to have several smaller knives on hand. A thin-edged steak knife, finely sharpened, will serve the purpose in many instances. Pictured here are professional Japanese scalpel-like cutting tools are known as *kiridashi*.

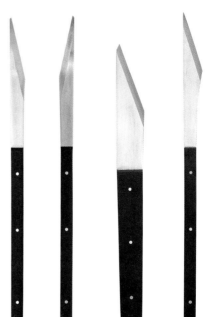

PEELERS

Peelers can be used for some of the garnishes in this book. Choose a sturdy one with a finely honed cutting edge. To make a clean, even cut, employ it slowly and steadily.

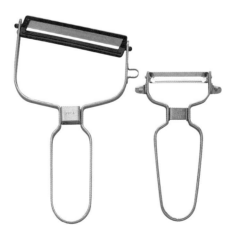

VARIOUS TOOLS

For miscellaneous work, I have a number of tools on hand. I include them here for your reference. Melon-ball scoops can be found in most kitchens, and most of you probably stock apple corers and some kind of pick. As for the rest of the tools, their functions can be covered by one or more everyday utensils. A role-call of the items from left to right, reads as follows: corers/punches, cork-screw punches (handle not shown), needle pick, melon-ball scoops, and pincers.

CORERS/PUNCHES

The circular corers have drawn some attention, so they are worth noting separately. These are sturdy, tubular tools with fine edges. When pressed against a food surface and rotated, they easily bore through the food. They are employed with cucumbers on pages 32 and 34, and with eggplant on page 78. As with food chisels, before using them protect the cutting surface and the tool's edge by laying out a kitchen towel.

I N D E X